IMAGES
of America

SALISBURY

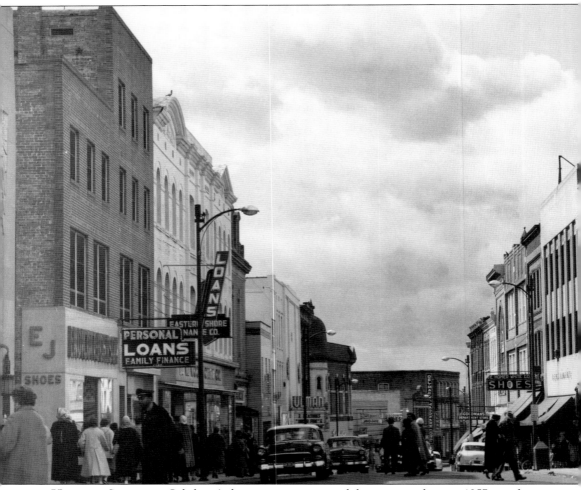

HEART OF SALISBURY. Salisbury's downtown commercial district, seen here in 1957, was for many years the heart of the city, providing the lifeblood for merchants and businesspeople while offering shopping and recreational opportunities for many others. Though its glory days have long since passed, the memories of literally hundreds of businesses that have come and gone from this section in the past century remain. (Courtesy of the Salisbury Area Chamber of Commerce.)

ON THE COVER: In the 1940s and 1950s, one of the most exciting summer events for area children was the Salisbury Jaycees' annual soapbox derby. Seen here in 1949, the event took place on East Main Street in front of Wicomico High School (now Wicomico Middle School), near Salisbury City Park. (Courtesy of the Salisbury Jaycees.)

IMAGES
of America

SALISBURY

Jason Rhodes

ARCADIA
PUBLISHING

Published by Arcadia Publishing
Charleston, South Carolina

Printed in the United States of America

Library of Congress Control Number: 2010930262

For all general information, please contact Arcadia Publishing:
Telephone 843-853-2070
Fax 843-853-0044
E-mail sales@arcadiapublishing.com
For customer service and orders:
Toll-Free 1-888-313-2665

Visit us on the Internet at www.arcadiapublishing.com

*To my grandmother, Nina Fuller, who has supported
my every endeavor for more than three decades*

CONTENTS

ACKNOWLEDGMENTS

Since its founding, the Edward H. Nabb Research Center for Delmarva History and Culture at Salisbury University has served as a public repository for some of the most significant documents and images to chronicle the history of the tristate peninsula. Without the help of the center and its director, Dr. G. Ray Thompson, as well as administrative assistant Donna Messick and assistant Heather Burnham, this book would not have been possible.

Thanks to others who were kind enough to offer information, images, and access to their collections for this project: Salisbury University, the Salisbury Area Chamber of Commerce, the Salisbury Jaycees, Perdue Incorporated, Etta Lokey, Michele Thomas, and my father, Frank Rhodes. Special thanks go to my fiancée, Kelly Saul, and her daughter, Lauryn Dennis, for their understanding and support during this undertaking.

Unless otherwise noted, all images appear courtesy of the author's family collection.

INTRODUCTION

In 1732, Salisbury Towne was founded on the eastern coast of Maryland on 15 acres belonging to William Winder. The town flourished, and upon the founding of Wicomico County in 1867, Salisbury became its county seat. Two events in the 1920s contributed greatly to the town's growth: the founding of Salisbury State Normal School and the small family egg farm of Arthur W. Perdue. As these two institutions grew into what are now Salisbury University and international poultry giant Perdue Incorporated, so did the town around them. Today they, along with Peninsula Regional Medical Center and Wicomico County, are the city's largest employers and best-known institutions. By the 1860s, Salisbury had gained a reputation as the "Crossroads of the Eastern Shore," a fitting nickname for what is today the largest city between Virginia Beach, Virginia, and Annapolis, Maryland.

Salisbury's early years were not without contention. When Somerset County, where the town was originally established, was divided in two and its southern half renamed Worcester County, land owner John Caldwell petitioned for Salisbury to become the county seat of what remained of the original Somerset. His bid was unsuccessful, and as if to add insult to injury, the dividing line between the counties was drawn directly over his property and through Salisbury itself, placing half the town in Somerset and half in Worcester County.

In 1817, the Maryland legislature appointed commissioners to survey Salisbury Towne, resulting in a call to realign Division Street, though the recommendation was never acted upon. Salisbury became an incorporated city in 1854, just six years before fire consumed much of the area in 1860.

That same year, Union troops from Salisbury and nearby Cambridge, Maryland, were stationed in the city at Camp Upton to help protect the telegraph line that spanned the shore as the area prepared for the Civil War. Salisbury's proximity to the Mason–Dixon Line increased the possibility of a potential attack from Confederate soldiers.

The city's population in 1860 was placed at just over 2,400. Its first rail line was laid that year, giving its residents easy access to long-distance inland travel, and vice versa, for the first time. Salisbury's first hotel anticipated business from this new venture until it burned in the fire. The railroad's increased shipping access and the U.S. Military's need for items produced in the city, including timber and fruits and vegetables to feed troops, helped Salisbury become an economic powerhouse by the end of the war.

Before rail travel, the Wicomico River played an important role in the city's early economy, providing a port for imports and exports, including lumber, fertilizer, and produce. By the mid-1800s, passenger steamboat service arrived in the area. In 1923, an overnight roundtrip ticket to Baltimore aboard the steamer *Virginia* was $5 ($3.24 one way). Staterooms could be had from $1.25 to $2.75, with meals ranging from 75¢ to $1. The line also provided travel to other Maryland ports, including Quantico, Allen, Widgeon, White Haven, Mount Vernon, Bivalve, Nanticoke, Deal Island, Wingate Point, Hooper Island, and Cambridge.

In 1886, fire once again destroyed the city; however, its citizens rebounded. By 1888, Salisbury had a population of approximately 3,900. A mayoral form of government was established that year, and new zoning laws were passed to help lessen the chance of another fire as devastating as the 1886 blaze, known as the Great Salisbury Fire. From that point on, wood-frame structures were banned in the central business district.

In 1867, Salisbury became the county seat of the newly created Wicomico County. One of its inaugural problems was how to educate its children. Schoolhouses built from the coffers of Somerset and Worcester Counties remained the property of those counties, and those in the areas that became part of Wicomico County were shuttered. Officials from a private school, Salisbury Academy, stepped forward to help, working with the new county and the City of Salisbury to establish Salisbury's first public high school.

By the early 1900s, Salisbury had its first electric lights and a paved Main Street (in lieu of the oyster shell streets that still served much of the rest of the city), and its residents had caught baseball fever. Salisbury's first official city team was formed about 1896, with professional teams such as the Salisbury White Clouds and Indians following soon behind. Athletics have remained an important part of the city throughout the years. From 1964 to 1976, Salisbury held the nickname "Tennis Town, U.S.A." as host of the National Indoor Tennis Championships.

Local culture received a boost in 1936 with the establishment of the Salisbury Community Concert Association. Two years later, the more successful Salisbury Cooperative Concert Association was formed with nearly 900 members. The association brought a variety of guest artists to the area over the course of several decades. Today organizations including the Salisbury Community Band, Salisbury Symphony Orchestra, and Salisbury Youth Orchestra continue that musical tradition.

The Community Players, today one of Maryland's longest continuously active theater troupes, was founded in 1938. The Salisbury-Wicomico Arts Council held its first meeting in 1967 and established a permanent presence in the city with an office and full-time executive director in 1981.

In the 1940s and 1950s, Salisbury became a hub of industry, with everything from frozen foods to gasoline pumps and boats to recreational vehicles being processed or manufactured in the city. The manufacturing bubble largely burst in the 1990s and 2000s, as many of those businesses closed or relocated. In 1968, aviation pioneer Richard A. Henson brought a different kind of industry to the city, making it the base of operations for his Henson Airlines. Its successor, U.S. Airways Express, continues to provide daily flights from the Salisbury–Ocean City Wicomico Regional Airport.

Henson is one of many philanthropists who helped build Salisbury. Though he died in 2002, his foundation has gone on to fund major improvements in the area, as has the Arthur W. Perdue Foundation. They have picked up the gauntlet laid down by earlier city philanthropists, such as the Elihu and William Jackson family, responsible for many of Salisbury's earliest institutions, including Peninsula General Hospital and several houses of worship.

Salisbury has come a long way since its founding in 1732. Today the city's population has grown to nearly 30,000, the municipality covering some 11.4 square miles compared to its original 15-acre plot. This book celebrates the people and events that helped Salisbury Towne grow into the city it is today.

One

ON THE WATERFRONT

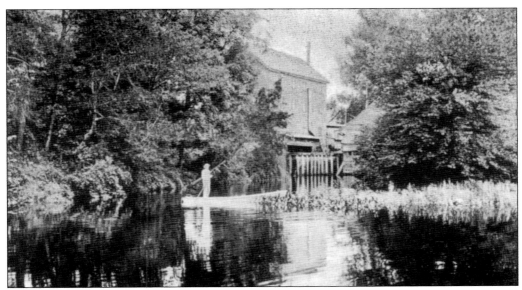

OLD MILL DAM. A man identified only as "Mr. Wilson" paddles a skiff in front of Salisbury's old mill dam on the Wicomico River in 1903. Wilson operated the dam, which was located near what is now the intersection of South Division and Market Streets, where the Wicomico County Public Library stands. The building next to the mill is a fish hatchery. It later became the city's first shirt factory, powered by the running water.

HUMPHREYS LAKE. Once a significant part of Salisbury's landscape, Humphreys Lake fed the old mill dam. It was named for Gen. Thomas Humphreys, who purchased the gristmill from the Reverend James Laird about 1805. The water covered more than a mile-long stretch of what is now Salisbury's downtown area. The dam that created it served as an access point for horse-drawn vehicles coming into Salisbury.

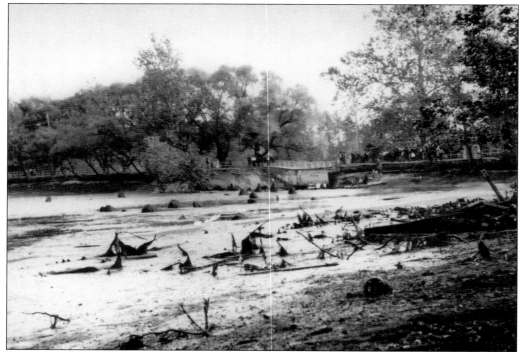

THE DAM BREAK. When the old mill dam collapsed in 1909, local residents saw an opportunity. The dam had become obsolete with the advent of automobiles, which it was too narrow to accommodate. When the water receded into the natural course of the Wicomico River, the newly barren lakebed became an ideal location for a new retail district. (Courtesy of the Edward H. Nabb Research Center at Salisbury University, Wicomico Historical Society Collection.)

Johnson's Pond. Seen here in 1888, Johnson's Pond was another early mill pond in Salisbury. Originally called H. Humphreys Pond, it is located near Isabella Street. The pond encompasses 104 acres with a maximum depth of 11 feet, making it the largest impoundment pond on Maryland's Eastern Shore. Today it is used exclusively for recreation, with its sport fish populations managed by the Maryland Department of Natural Resources.

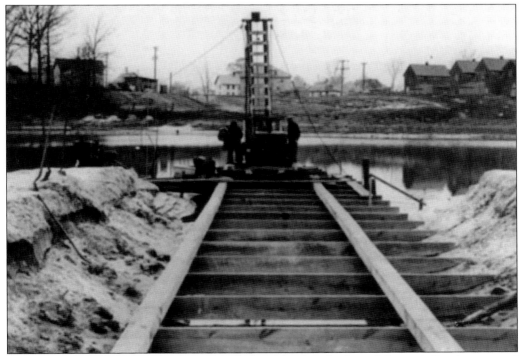

Replacing the Dam. Unlike the old mill dam, the dam built on Johnson's Pond generated hydroelectric power for the city while turning mills for grist, lumber, and wool carding owned by H. Humphreys. When it washed out in 1926 and again in 1933, the resulting floods covered much of Isabella Street. In 1936, the dam was rebuilt farther upstream as a federal Works Progress Administration project.

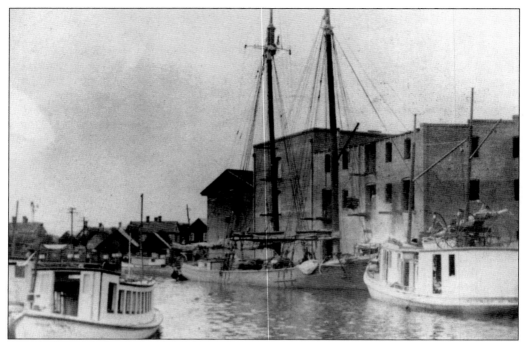

PORT EXCHANGE. Salisbury's location on the river made it a popular port city in the 18th and 19th centuries. The port exchange, seen here about 1895, served as a marketplace for those who had commercial goods to sell. Today, renovated on the inside, it continues its commercial service as an office complex. (Courtesy of the Edward H. Nabb Research Center at Salisbury University, Wicomico Historical Society Collection.)

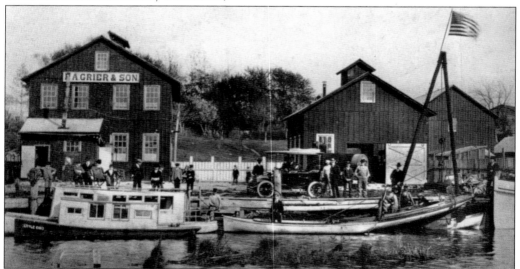

WICOMICO RIVER. The river provided many different livelihoods for a number of Salisbury's residents. With boats constantly traveling in and out of port, Fred Grier, who came to Salisbury with his brother, Robert, in 1888, saw an opportunity. After working with his brother for a time, he opened his own machine shop and boat engine repair firm, F. A. Grier and Son, seen on the left in this image about 1903.

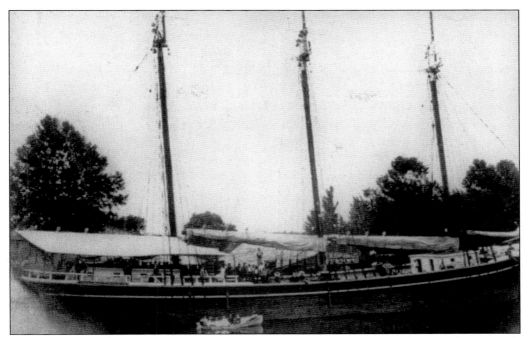

COMMERCE ON THE RIVER. The Wicomico River also served as a means for profit for those outside the area. In this *c.* 1898 image, a schooner from the J. S. Hoskins Lumber Company of Baltimore is delivering cedar shingles from Florida to Salisbury's Tilghman Company for use by builders on the Eastern Shore. (Courtesy of the Edward H. Nabb Research Center at Salisbury University, Wicomico Historical Society Collection.)

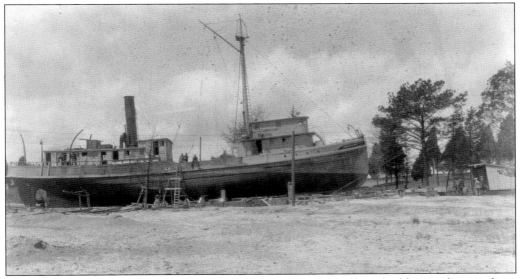

WORKING THE WATER. Salisbury has been home to a number of boat building and repair firms throughout the years. Companies have built and refurbished vessels from pleasure boats to those used in shipping and harvesting seafood. The ship *James M. Gifford*, seen here under repair in 1940, is one of the latter, having been built for the Lewes Fisheries Company of Delaware, which was established in 1911. (Courtesy of the Salisbury Area Chamber of Commerce.)

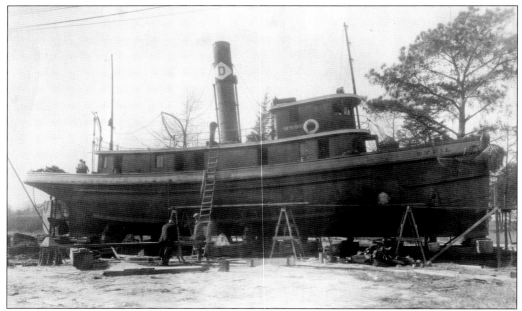

A DIFFERENT KIND OF WORKBOAT. Other vessels, such as the tugboat *Sybil*, seen here at a Salisbury shipyard about 1948, worked the water in a different way, providing services to other craft. Shipbuilding is said to have been the first profession to take root in Salisbury, beginning in the 18th century. (Courtesy of the Salisbury Area Chamber of Commerce.)

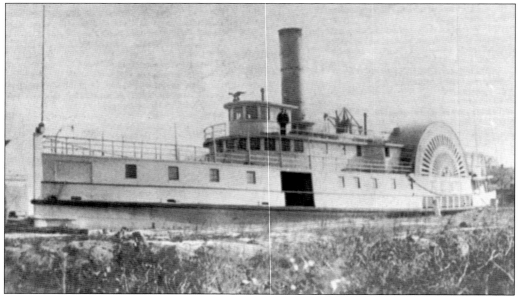

STEAMBOAT TRAVEL. Of course, the Wicomico River also allowed easy access for passenger travel along the waterways of the Mid-Atlantic and beyond. The steamboat *Kent* is believed to be the first ship offering regular passenger service in Salisbury, beginning in 1855. (Courtesy of the Salisbury Area Chamber of Commerce.)

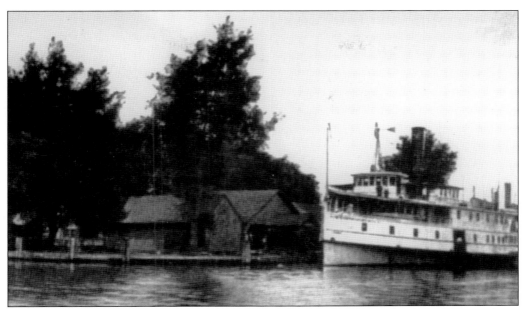

STEAMBOAT *VIRGINIA*. While the *Kent's* time in Salisbury was short-lived, other passenger ships, such as the popular *Virginia*, later filled the void. Built in 1903, the *Virginia* was operated by the Baltimore, Chesapeake, and Atlantic Railroad (BC&A) and provided service from Salisbury to Baltimore until 1924, when it was relocated to a more southern Eastern Shore base in Crisfield. (Courtesy of the Salisbury Area Chamber of Commerce.)

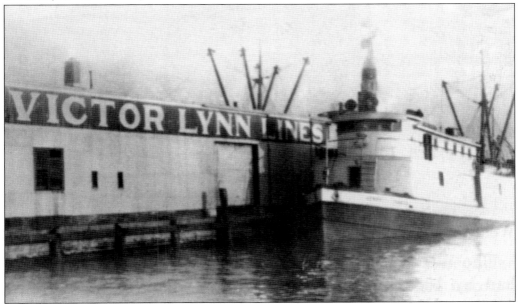

VICTOR LYNN. The *Victor Lynn*, seen here in the 1930s, provided freight service from Salisbury until 1954. A project that dredged the Wicomico River's depth to 9 feet in 1888 made it easier for vessels to enter the port. A second dredging project in 1931 increased the port's depth to 13 feet, allowing for even larger boats to serve the area. (Courtesy of the Salisbury Area Chamber of Commerce.)

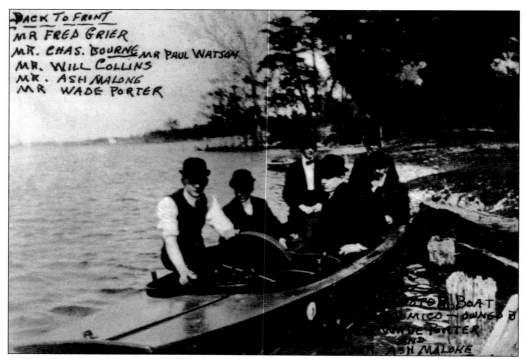

A New Form of Leisure. In 1901, a new means of recreation was introduced as local residents Wade Porter and Ash Malone purchased the first known motorboat in Salisbury. Seen in this photograph, taken on June 5 of that year, are, from front to back, Porter, Malone, Will Collins, Paul Watson, Charles Bourne, and Fred Grier. (Courtesy of the Edward H. Nabb Research Center at Salisbury University, Wicomico Historical Society Collection.)

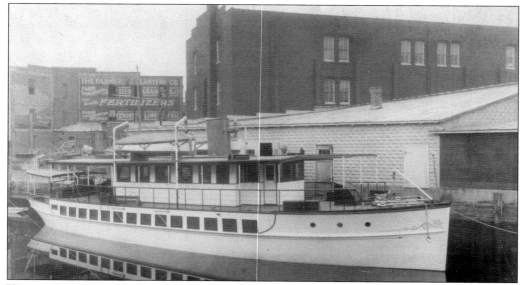

Yacht Wilanna, 1950. Over the next half century, recreational boating continued to thrive in Salisbury, though some of the vessels became much larger and provided many more amenities, such as indoor seating, as seen here. (Courtesy of the Salisbury Area Chamber of Commerce.)

Two

By Land and Air

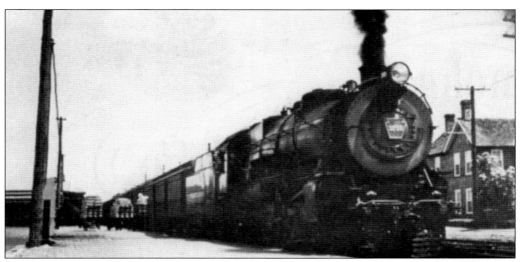

RIDING THE RAILS. The establishment of the Eastern Shore Railway in 1853 marked the beginning of rail travel throughout much of the Delmarva Peninsula, including Salisbury, though its progress did not flourish until after the Civil War. Offshoot lines, such as the Wicomico and Pocomoke Railroad Company, founded in 1864, also served the area. The train in this picture, traveling south, was part of the Pennsylvania Railroad. (Courtesy of the Salisbury Area Chamber of Commerce.)

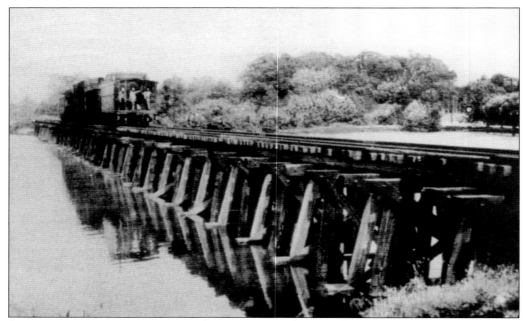

JOHNSON'S POND TRESTLE. By 1876, the Wicomico and Pocomoke Railroad had established a line from Salisbury to the popular beach resort of Ocean City. The Baltimore and Eastern Shore Railroad built a connecting line from Claiborne to Salisbury in 1890. By 1894, the BC&A had taken over the line, of which this trestle was a part, continuing service until 1928. (Courtesy of the Edward H. Nabb Research Center at Salisbury University, Wicomico Historical Society Collection.)

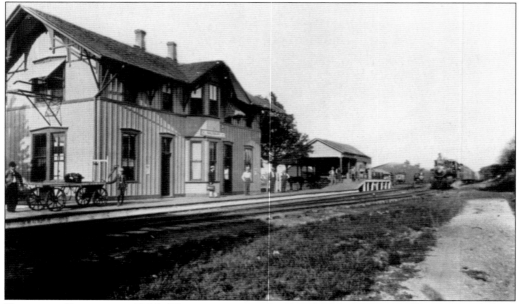

RAILROAD STATION, C. 1905. This two-story station is what passengers pulling into Salisbury on the Claiborne line would have seen until the mid-1910s. After leaving Salisbury, the train made stops at Walston Switch, Parsonsburg, Pittsville, Willards, Whaleyville, St. Martin, Berlin, Diricksons, Sinepuxent, and West Ocean City on its way to Ocean City.

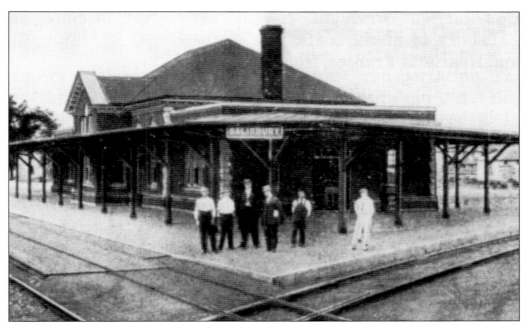

UNION STATION. In 1914, this new, more modern passenger station opened in Salisbury. The crossed tracks in front represent the intersection of the BC&A and New York, Pennsylvania, and Norfolk Railroads. The station was converted to a freight station in 1958 and listed on the National Register of Historic Places in 2007. (Courtesy of the Salisbury Area Chamber of Commerce.)

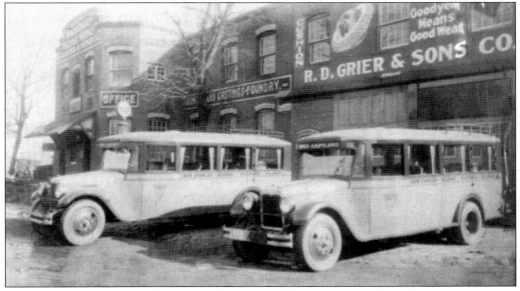

EASTERN SHORE TRANSIT LINE. By the early 20th century, bus service became the choice for many traveling on short-haul trips to other towns on the Lower Eastern Shore. These buses, seen in front of the machine shop of R. D. Grier and Sons Company, provided service between Salisbury and Cape Charles, Virginia. Another service, the Peninsula Rapid Transit Company, founded in 1915, made connections in Fairmount, Berlin, Hebron, and Delmar, Maryland. (Courtesy of the Salisbury Area Chamber of Commerce.)

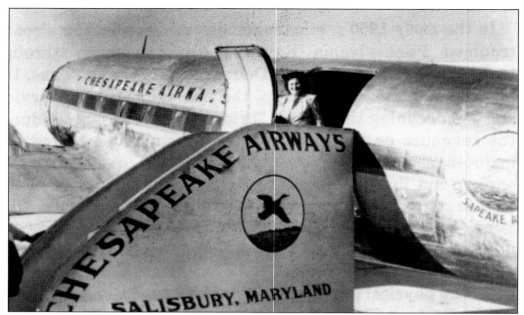

CHESAPEAKE AIRWAYS. This company made its first passenger flight from Salisbury on April 5, 1946, the same year Emma Davis Thurston posed for this publicity photograph. The airline served as a connector between Salisbury and Baltimore's Friendship Airport until 1949. Its owners' inability to secure a federal mail-carrying subsidy was said to be a factor in the business's demise. (Courtesy of the Salisbury Area Chamber of Commerce.)

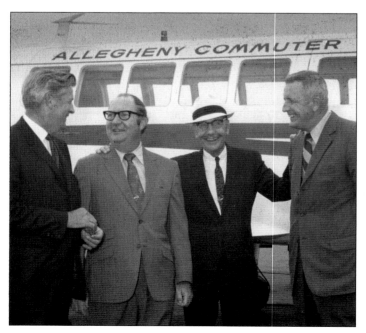

HENSON AIRLINES. Aviation pioneer and philanthropist Richard A. Henson, second from right, founded Henson Airlines, the first commuter airline, in Hagerstown, Maryland, in 1962. He had expanded his reach under the Allegheny Commuter brand before moving operations to Salisbury in 1968. In 1983, he moved his affiliation to Piedmont Aviation. US Airways purchased Piedmont in 1989 and continues to provide daily commuter service from Salisbury. (Courtesy of the Salisbury Area Chamber of Commerce.)

Three

IN GOD WE TRUST

HUMPHREYS LAKE BAPTISM. Early religious leaders did not need fancy fonts to conduct baptisms. They simply used the water sources nature provided. In this instance, Humphreys Pond served as a convenient site to christen new followers of the Methodist Church. (Courtesy of the Edward H. Nabb Research Center at Salisbury University, Wicomico Historical Society Collection.)

ALLEN MEMORIAL BAPTIST CHURCH. Built in 1937 to replace the original North Division Street Baptist Church at the intersection of North Division and East Chestnut Streets, the building seen here served the congregation of the renamed Allen Memorial Baptist Church until the early 21st century, when a new, larger church was built on Snow Hill Road. (Courtesy of the Salisbury Area Chamber of Commerce.)

ASBURY UNITED METHODIST CHURCH. Founded in 1778, Asbury United Methodist Church has ties to one of the oldest churches in Salisbury. The Little Red Meeting House was built for Methodist worship on the site of Asbury's first location on North Division Street in 1881. In 1953, Asbury's congregation purchased 11 acres on Camden Avenue, where the current building, seen here, was consecrated on May 10, 1963. A fellowship hall was added in 1968. (Courtesy of the Salisbury Area Chamber of Commerce.)

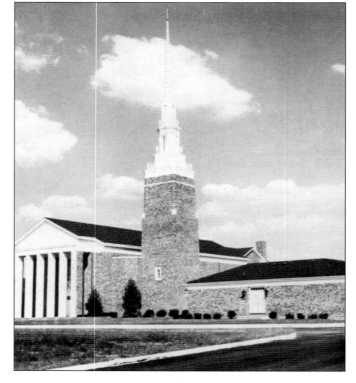

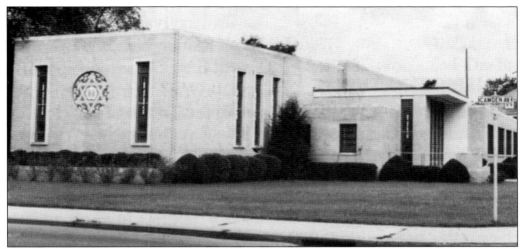

BETH ISRAEL SYNAGOGUE. Founded in 1925, Salisbury's Kahelas Israel Congregation originally consisted of just nine families meeting on the second floor of I. L. Benjamin's store on Main Street. As the congregation grew, so did the need for a permanent facility. In 1951, the renamed Beth Israel congregation opened its synagogue on Camden Avenue, where it continues to serve the city's Jewish faith population. (Courtesy of the Salisbury Area Chamber of Commerce.)

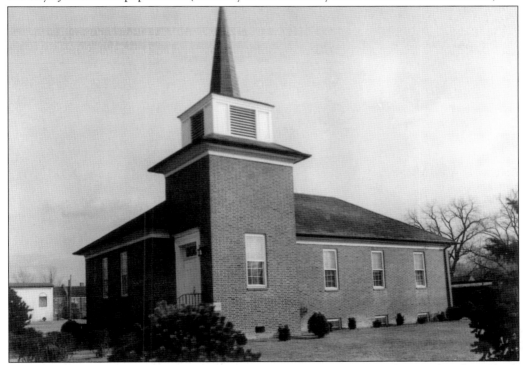

BETHANY LUTHERAN CHURCH. Dedicated on May 29, 1949, Bethany Lutheran Church was built to support the growing number of Lutherans who called Salisbury home by the mid-20th century. It continues to serve the community today at the corner of Camden Avenue and South Street. (Courtesy of the Edward H. Nabb Research Center at Salisbury University, Wicomico Historical Society Collection.)

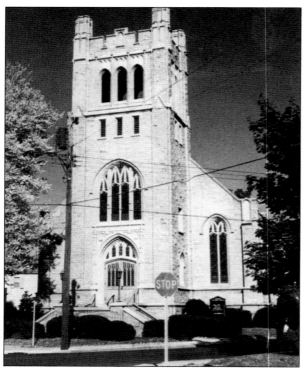

BETHESDA METHODIST PROTESTANT CHURCH. Founded in 1842, Salisbury's Methodist Protestant congregation established its first permanent building in the city some 30 years later. In 1896, it adopted the name "Bethany." As the congregation grew, a new building was needed. The church purchased a parcel at North Division and William Streets, dedicating the building seen here on June 3, 1923. An addition to the building was completed in 1926. (Courtesy of the Salisbury Area Chamber of Commerce.)

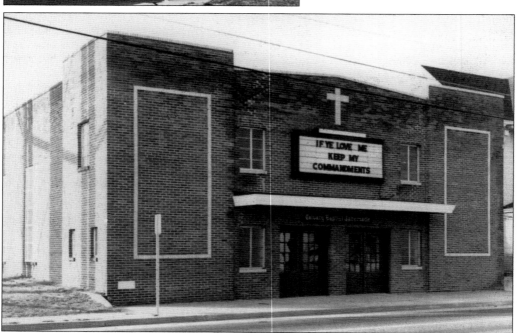

CALVARY BAPTIST TABERNACLE. The Calvary Baptist Tabernacle once called this theater-style building home. The congregation now meets at a more traditional church building on Tilghman Road. (Courtesy of the Edward H. Nabb Research Center at Salisbury University, Wicomico Historical Society Collection.)

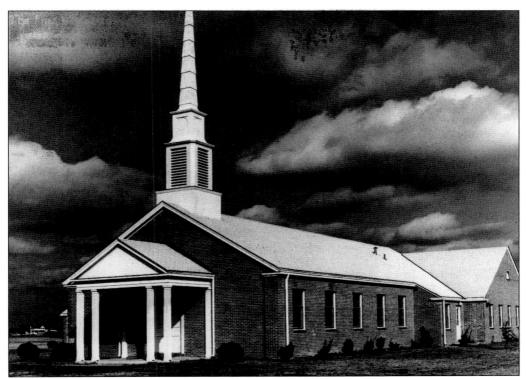

CHRIST UNITED METHODIST CHURCH. Located on Phillip Morris Drive, Christ United Methodist Church evolved from this building to a more modern structure, where everything from traditional services and youth activities to a food pantry and part-time homeless shelter are provided. (Courtesy of the Edward H. Nabb Research Center at Salisbury University, Wicomico Historical Society Collection.)

CHURCH OF CHRIST. Like many other local houses of worship, this nondenominational New Testament church on Old Ocean City Road has expanded greatly since this photograph was taken. Today the church holds regular Sunday worship and weekday bible classes. (Courtesy of the Edward H. Nabb Research Center at Salisbury University, Wicomico Historical Society Collection.)

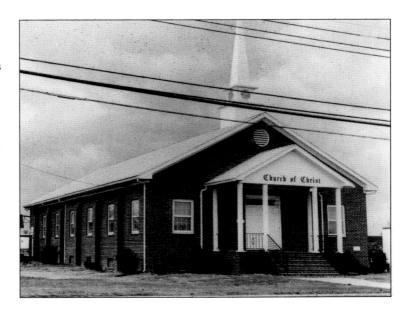

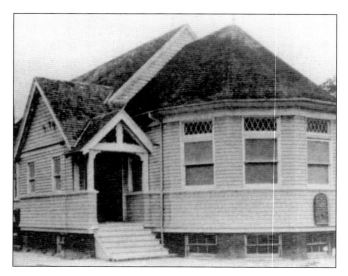

DIVISION STREET BAPTIST CHURCH. Founded by 11 community members led by Dr. and Mrs. Samuel J. Ker, Division Street Baptist was located at North Division and East Chestnut Streets. This building replaced the original church in 1898 after the inaugural building burned. The church continued to serve its congregation until 1937, when it was replaced by Allen Memorial Baptist Church. (Courtesy of the Edward H. Nabb Research Center at Salisbury University, Wicomico Historical Society Collection.)

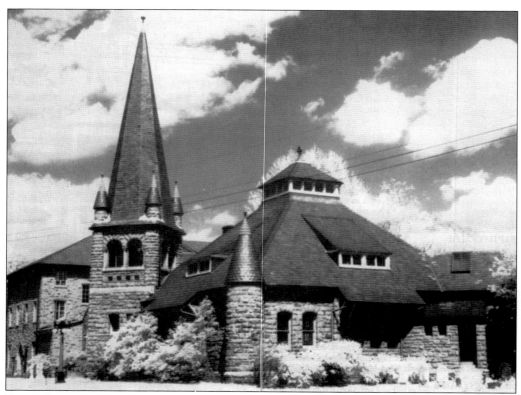

FAITH COMMUNITY CHURCH. This stone structure was originally built for Asbury Methodist Episcopal Church after fire destroyed its original wood-frame building in 1886. Following the reunification of the Methodist church, Asbury became one of three United Methodist churches within a two-block section of North Division Street. When it moved to its new building on Camden Avenue in 1963, this building was sold, becoming the home of Faith Community Church. (Courtesy of the Salisbury Area Chamber of Commerce.)

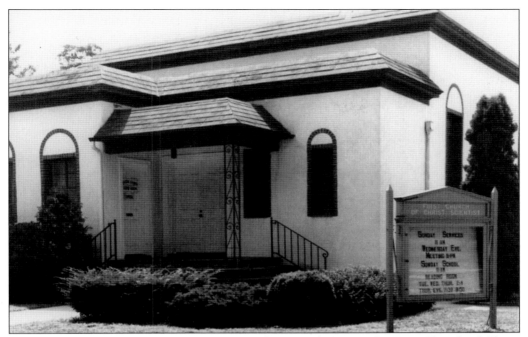

FIRST CHURCH OF CHRIST SCIENTIST. Located on Smith Street, the First Church of Christ Scientist is the local home of the national denomination founded in Boston, Massachusetts, in 1879. A more modern building has replaced the one seen here. The sign in this image advertises not only church services, but a reading room. (Courtesy of the Edward H. Nabb Research Center at Salisbury University, Wicomico Historical Society Collection.)

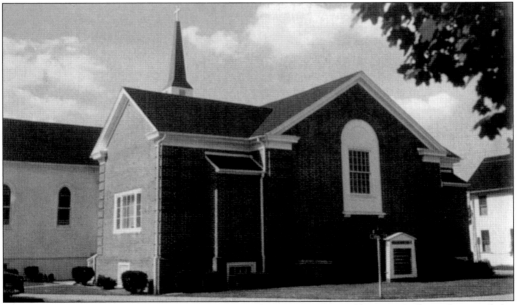

GRACE METHODIST CHURCH. Philanthropist and congressman William H. Jackson financed the lease to establish Grace Methodist Church on Anne Street under the auspices of the Reverend John W. Hardesty in 1908. Hardesty named the church "Grace" in honor of Jackson's daughter.

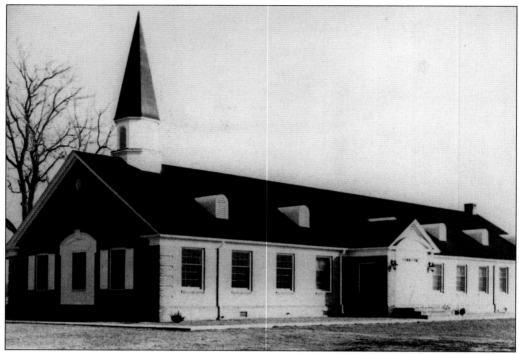

IMMANUEL BAPTIST CHURCH. Founded in October 1958 as a ministry of Allen Memorial Baptist Church to serve the east side of Salisbury, the congregation of Immanuel Baptist originally met at the Seventh Day Adventist Church on East Main Street. The current building, seen here, was dedicated in October 1964 on land donated for the church on Old Ocean City Road. (Courtesy of the Edward H. Nabb Research Center at Salisbury University, Wicomico Historical Society Collection.)

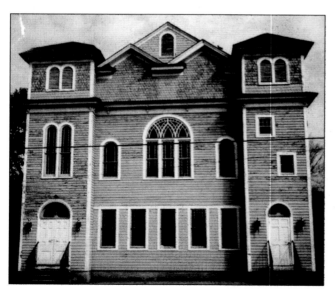

JOHN WESLEY M. E. CHURCH. Founded by five freedmen in 1838, this Broad Street church served Salisbury's African American community. In 1994, the building became the Charles H. Chipman Cultural Center, named in memory of a prominent local educator who later owned the building. The center and its parent organization, the Chipman Foundation, are dedicated to preserving the history of Eastern Shore African American communities. (Courtesy of the Edward H. Nabb Research Center at Salisbury University, Wicomico Historical Society Collection.)

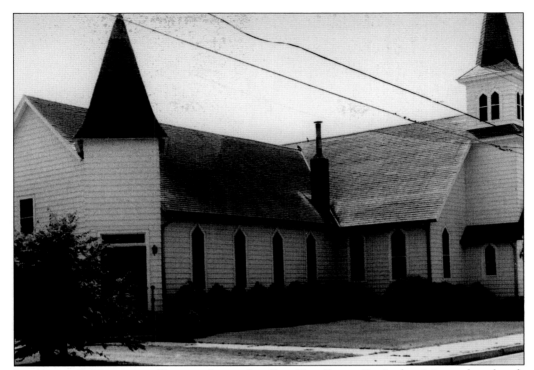

ST. ANDREW'S METHODIST CHURCH. Located on East Vine Street, St. Andrew's is another church that has long served Salisbury's Methodist population. (Courtesy of the Edward H. Nabb Research Center at Salisbury University, Wicomico Historical Society Collection.)

ST. BARTHOLOMEW'S CHURCH. Also known as Old Green Hill Church, this building was constructed in 1773 to replace what is believed to have been Wicomico County's first Episcopal church building, erected in the 1690s. Its location on the Wicomico River was selected due to its central location among the plantations of the unincorporated area then known as Green Hill Towne and Porte. (Courtesy of the Salisbury Area Chamber of Commerce.)

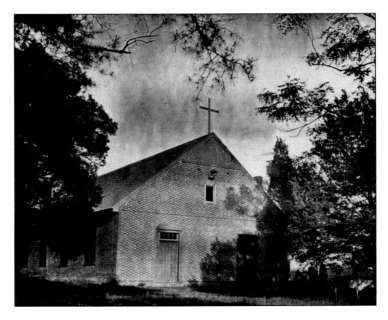

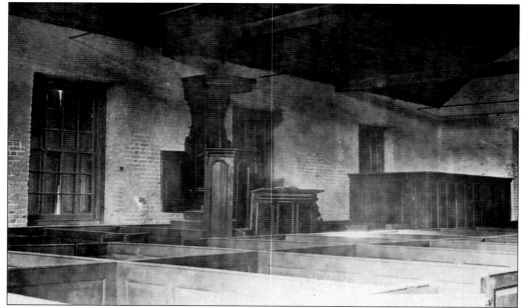

INSIDE ST. BARTHOLOMEW'S. Though the church, located in the area known today as Quantico, became obsolete as settlements expanded and moved farther south, it continues to stand as a historical landmark. It is still used each August during an annual St. Bartholomew's service held by the Episcopal Church. (Courtesy of the Salisbury Area Chamber of Commerce.)

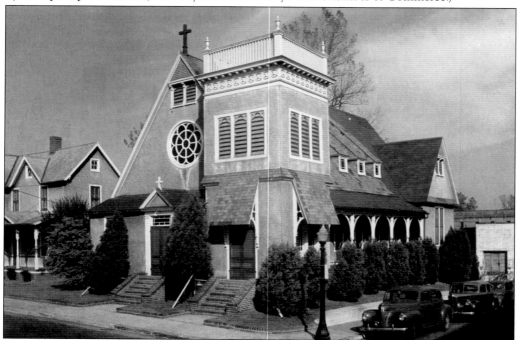

ST. FRANCIS DE SALES ROMAN CATHOLIC CHURCH. Salisbury's Catholic community was first served by St. Francis upon its dedication in this building at the intersection of Calvert and Bond Streets in 1916. The house at left served as the rectory.

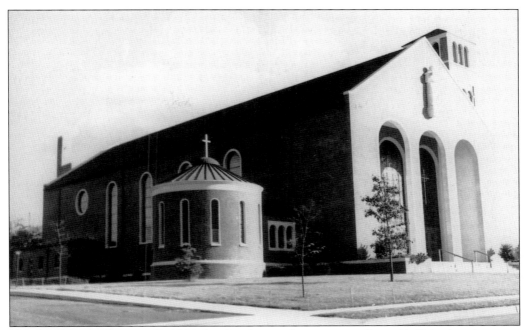

New St. Francis Church. In 1964, the church moved to its present Riverside Drive location, seen here, on property donated by John E. Morris. Adjacent property was purchased for construction of a rectory and parochial school. (Courtesy of the Edward H. Nabb Research Center at Salisbury University, Wicomico Historical Society Collection.)

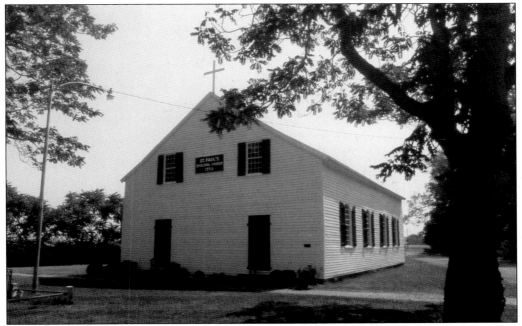

St. Paul's Church, 1980. Dedicated in 1724 in Hebron, Maryland, near Salisbury, St. Paul's was originally an Episcopal chapel of ease before becoming the main church of the Spring Hill Parish in 1827. The church was rebuilt in 1773.

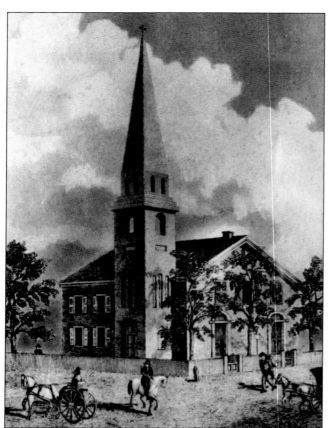

OLD ST. PETER'S CHURCH, C. 1845. This church was founded in 1824 as Goddard's Chapel, taking on alternate names over the years, including Head of the River Chapel, Wicomico Chapel, Salisbury Chapel, and finally, St. Peter's Chapel. Its first building was constructed on St. Peter's Street in 1772 and burned in 1860. Its replacement, seen here, was dedicated in 1862. (Courtesy of the Edward H. Nabb Research Center at Salisbury University, Wicomico Historical Society Collection.)

ST. PETER'S EPISCOPAL CHURCH. Construction of the current St. Peter's began in June 1887, incorporating bricks from the first and second buildings into its foundation. The first service in the new building was held on Christmas of that year. (Courtesy of the Salisbury Area Chamber of Commerce.)

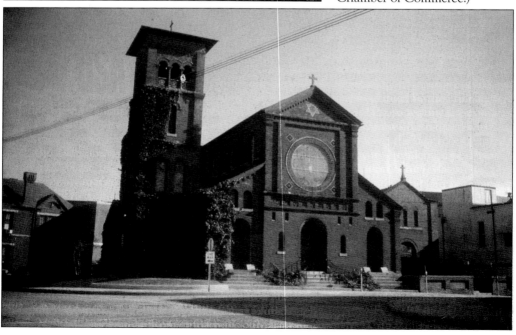

INSIDE ST. PETER'S EPISCOPAL CHURCH. The interior of the new church was as ornate as that of its predecessor. In addition to holding regular services, the church also controls nearby Parsons Cemetery, founded by an 1873 bequest from deceased former Bank of Salisbury president Benjamin Parsons. (Courtesy of the Salisbury Area Chamber of Commerce.)

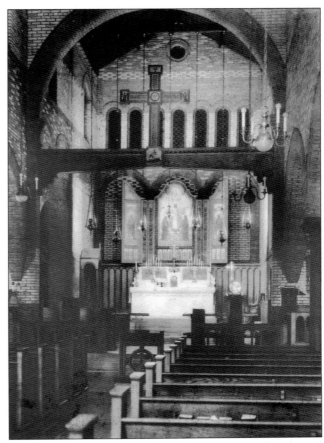

TRINITY METHODIST EPISCOPAL CHURCH. Founded in 1866, Trinity suffered back-to-back tragedies when its first two buildings were destroyed by fire in 1885 and 1886 before a third church was dedicated in 1887. As the congregation grew, it needed more space, prompting former Maryland governor and Wicomico County native Elihu E. Jackson to fund construction of this building, dedicated on North Division Street on May 21, 1905. (Courtesy of the Salisbury Area Chamber of Commerce.)

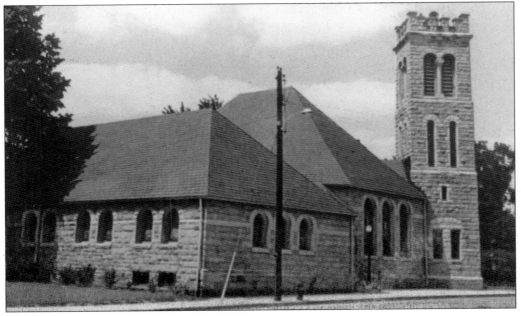

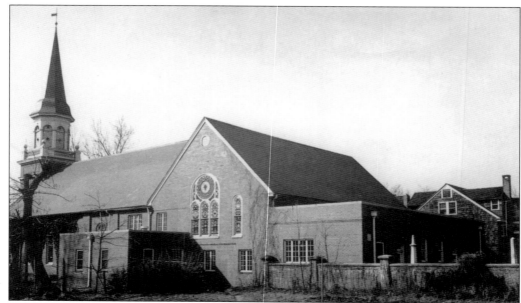

WICOMICO PRESBYTERIAN CHURCH, C. 1938. Like many Presbyterian churches on the Eastern Shore, Wicomico traces its history back to the Reverend Francis Mackemie, who founded the first Presbyterian church in the United States in adjacent Somerset County. Wicomico Presbyterian's original building was constructed in 1830. In 1859, the church moved to its current Broad Street location, seen here. (Courtesy of the Edward H. Nabb Research Center at Salisbury University, Wicomico Historical Society Collection.)

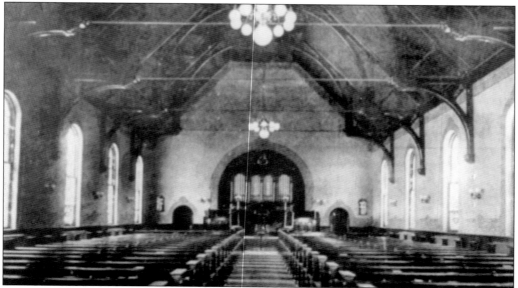

INSIDE WICOMICO PRESBYTERIAN CHURCH. Wicomico Presbyterian unveiled a greatly expanded building in 1941. The renovation included the demolition and rebuilding of the church's front tower, adding 12 feet to the front of the building, as well as a two-story Sunday school wing. (Courtesy of the Edward H. Nabb Research Center at Salisbury University, Wicomico Historical Society Collection.)

Four

SCHOOL DAYS

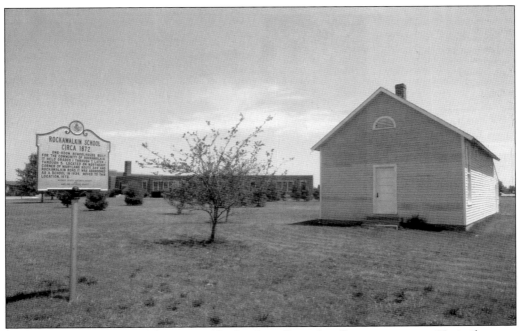

ROCKAWALKIN SCHOOL. Built in 1872, the Rockawalkin schoolhouse represents 23 similar one-room schools that educated children in Wicomico County during that era. Though it closed in 1939, it continues to serve as a local historical landmark. Its original cost of construction was $325. (Courtesy of the Salisbury Area Chamber of Commerce.)

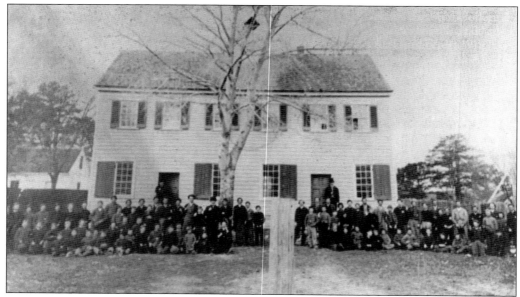

SALISBURY ACADEMY. Located at North Division and Chestnut Streets, this school opened in 1796, becoming a coed school in 1823. In 1872, the academy worked with Wicomico County to create Salisbury High School, the county's first free public secondary school. A new building was built for the school, while the academy building burned in the Great Salisbury Fire of 1886. (Courtesy of the Edward H. Nabb Research Center at Salisbury University, Wicomico Historical Society Collection.)

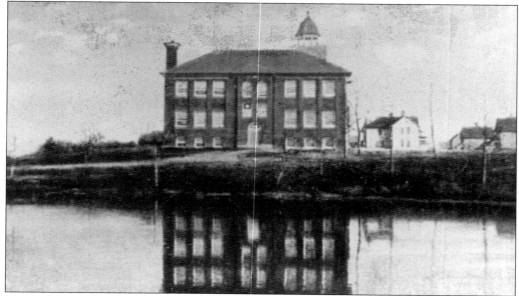

WICOMICO HIGH SCHOOL, 1906. With the addition of a 10th grade to the education system in 1902, Salisbury High School was found to be too small to continue serving as a central school for the county's eligible students, numbering more than 200. Legislators took action to bring a larger high school to Salisbury, and on August 1, 1906, Wicomico High School opened on Upton Street, its name reflecting its inclusiveness of the entire county.

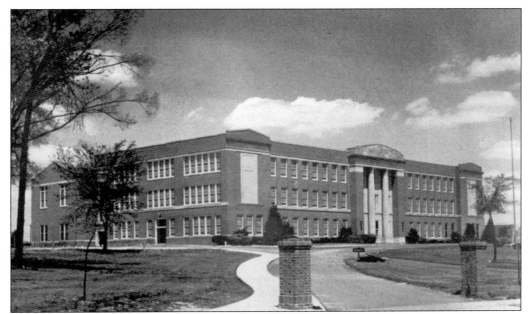

WICOMICO HIGH SCHOOL, 1948. By 1931, the county's growing high school population again made its current high school inadequately small. The county responded by opening this school on East Main Street during that same year. The county again built a new Wicomico High School to accommodate a growing student body in 1954—this time on Glen Avenue. The East Main Street school was then renovated into Wicomico Junior High School. (Courtesy of the Salisbury Area Chamber of Commerce.)

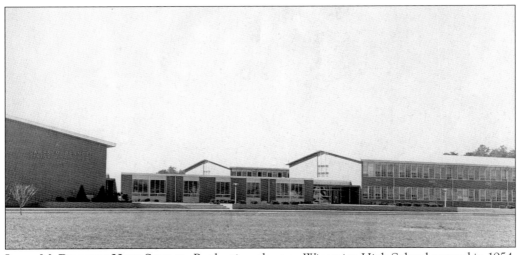

JAMES M. BENNETT HIGH SCHOOL. By the time the new Wicomico High School opened in 1954, it was one of only two high schools in the county. The county added Bennett on College Avenue as its third in 1962. The building seen here served until 2010, when a new Bennett High School was constructed nearby. In 1975, the county added a fourth high school, Parkside, on Salisbury's Beaglin Park Drive. (Courtesy of the Salisbury Area Chamber of Commerce.)

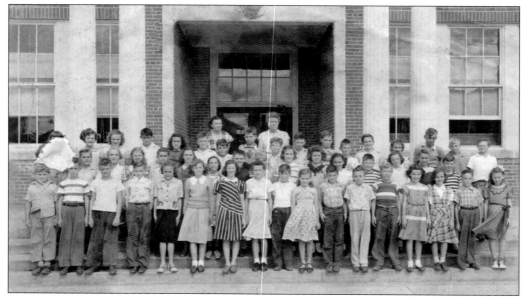

UPTON STREET ELEMENTARY SCHOOL. The original Wicomico High School became Upton Street Elementary in 1931, serving until its demolition in 1955. In this *c.* 1949 class photograph are, from left to right, (first row) William Baumann, Douglas Cooper, George Lee Figgs, William Bunting, Margaret Bromley, Eleanor Agge, Joyce Dickerson, Louise Bradford, David Dryden, Thelma Lokey, Edward Bird, Thomas Shokley, Billy Dury, Elizabeth Pusey, Phyllis Scarborough, Alfred Nelson, and Gloria Stroban; (second row) Pauline Bennett, Thomas Stevenson, Carole Waller, Charlotte Truitt, John ?, Ann Shockley, Barbara Knox, Don Wallett Doughty, Barbara Fooks, Peggy Waite, Joanne Figgs, Alice Pusey, Billy Sterling, Mary Webb, Jerry Parks, and Wilbur Nock; (third row) three unidentified, Benny Truitt, Betty Wilson, Whitley Williams, Charles ?, Lawrence Johnson, Thomas Wilson, Paul Trader, Russell Shockley, Richard Mills, Donald Long, Elaine Harrington, Vernon Wagner, Richard Truitt, and Paul Fye. The teachers are unidentified. (Courtesy of Etta Lokey.)

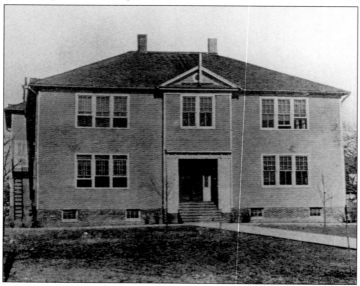

CAMDEN PRIMARY SCHOOL. Located on Carroll Street, this school served the city in the 1910s and 1920s. Its most notable principal was James M. Bennett, namesake of the county's third high school, who went on to become superintendent of Wicomico County Public Schools. (Courtesy of the Edward H. Nabb Research Center at Salisbury University, Wicomico Historical Society Collection.)

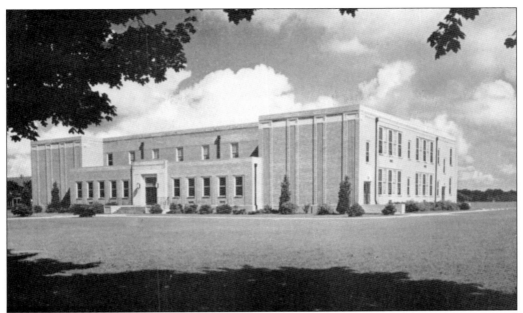

NORTH SALISBURY ELEMENTARY SCHOOL, 1948. Built in 1937 on Emerson Avenue, North Salisbury Elementary School was considered a replacement for two older area facilities: Bell Street School and Chestnut Street Grammar School. A $14 million renovation project in 2006 modernized North Salisbury, increasing its capacity to 570 students and making it one of the most technologically advanced schools in Wicomico County. (Courtesy of the Salisbury Area Chamber of Commerce.)

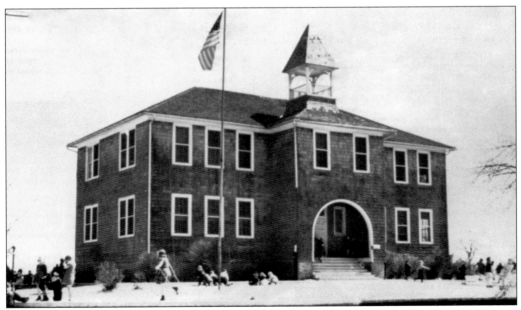

EAST SALISBURY SCHOOL, 1942. East Salisbury School opened in September 1942 on Old Ocean City Road to accommodate a growing elementary school–aged population. It has served continuously in the same location since. (Courtesy of the Salisbury Area Chamber of Commerce.)

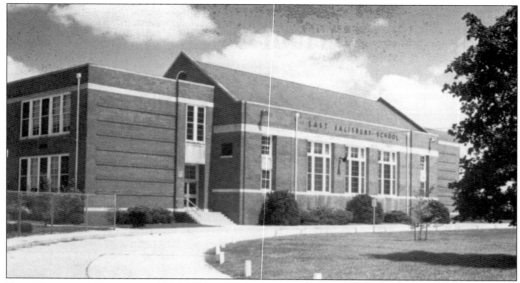

EAST SALISBURY SCHOOL, C. 1954. This school received the first of several upgrades and additions in 1954, when it was renovated into a 42,775-square-foot facility to better serve children reaching elementary school age following the post–World War II baby boom. It was expanded again in 1957, 1969, 1971, and 1983, having nearly doubled in size from the original 32,845-square-foot structure. (Courtesy of the Salisbury Area Chamber of Commerce.)

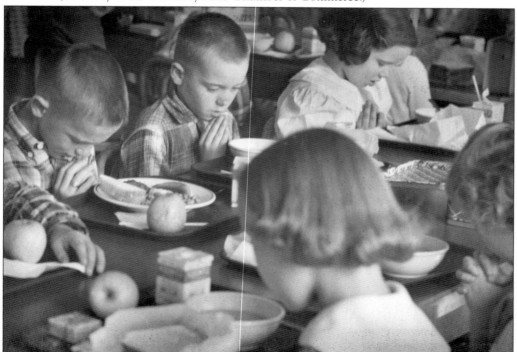

PEMBERTON ELEMENTARY SCHOOL. Prayer is not allowed in public schools today, but a blessing at lunchtime was standard at many schools when this photograph was taken in the 1950s. (Courtesy of the Salisbury Area Chamber of Commerce.)

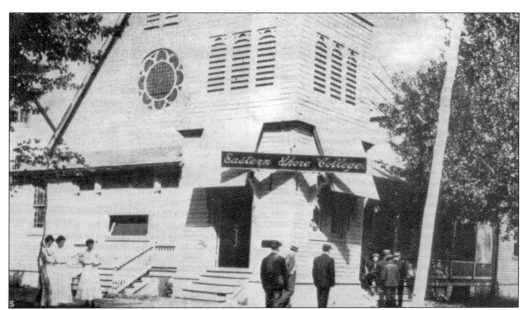

EASTERN SHORE COLLEGE. A private business school, Eastern Shore College was founded in 1910, offering business courses to those who wished to continue or pursue business education after high school. By 1916, the college was no more, and the building became the first home of St. Francis De Sales Roman Catholic Church. (Courtesy of the Salisbury Area Chamber of Commerce.)

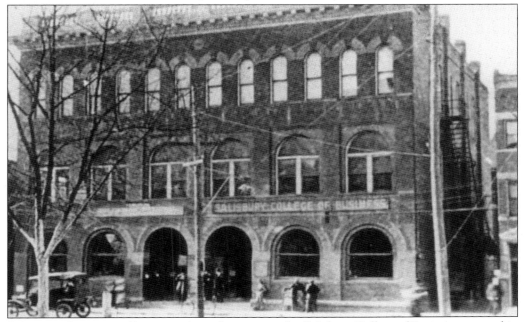

SALISBURY COLLEGE OF BUSINESS. A similar venture, the Salisbury College of Business operated in the early 20th century on the first floor of the Masonic Temple in downtown Salisbury. Independent business schools remained popular in the city well into the 1960s. In 1986, the Franklin P. Perdue School of Business was endowed by its namesake at Salisbury University, continuing the tradition of business education in the city.

BREAKING GROUND ON SALISBURY NORMAL SCHOOL. In 1922, the Maryland General Assembly established a commission to investigate the need for a teachers' college, or "normal school," on the Eastern Shore. Following a favorable report in 1924, ground was broken for the new school on 29 acres in Salisbury fronted by Camden Avenue. (Courtesy of Salisbury University.)

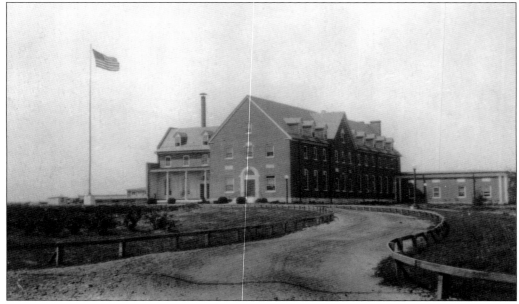

A LEGACY BEGINS. Salisbury State Normal School opened on September 7, 1925, with 12 administrators and faculty members, 61 elementary school–aged children, and just over 100 college students. Its first—and, until 1950, only—building was later named Holloway Hall in honor of the college's first principal, former Salisbury High School principal Dr. William J. Holloway. (Courtesy of Salisbury University.)

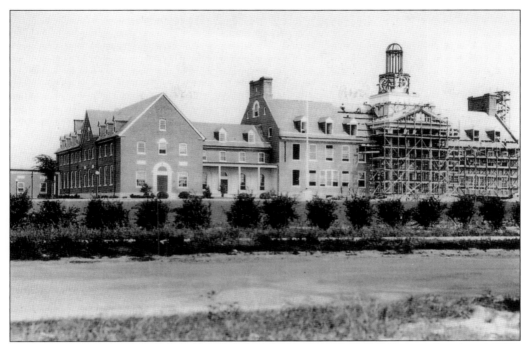

EXPANDING HOLLOWAY HALL. With new additions constructed in 1928 (seen here) and 1932, Holloway Hall included everything from student housing and administrative offices to college classrooms and two experiential classrooms in which the elementary school students were taught. (Courtesy of Salisbury University.)

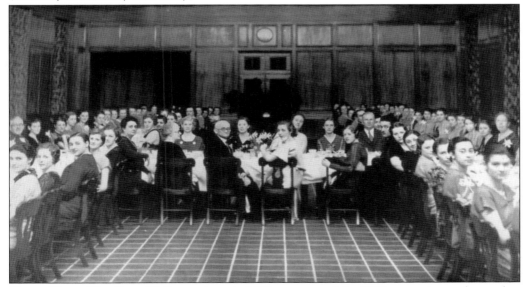

GREAT HALL. The Great Hall, seen here in 1933, was part of the 1932 expansion and served as the school's dining area. Students later ate meals at the Ruth Powell Dining Hall, which opened in 1966 (later replaced by the Commons in 1997). The adjacent Social Room hosted teas and other social events and served as a courting area for female students, who were not allowed guests in their rooms. (Courtesy of Salisbury University.)

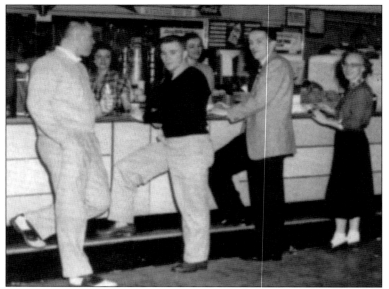

SNACK BAR. While the school expanded beyond Holloway Hall with its first all-male dormitory, Wicomico Hall, which opened in 1951 to accommodate post–World War II soldiers attending under the G.I. Bill, the bulk of its operation remained for many years in Holloway Hall. The school's snack bar, housed in Holloway's basement, is seen here in 1955. (Courtesy of Salisbury University.)

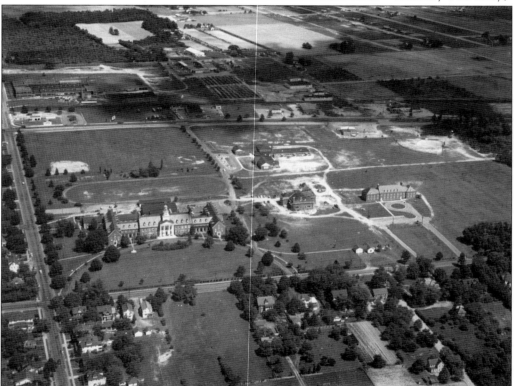

SALISBURY STATE COLLEGE. The school expanded and changed names several times during its first 76 years. It became Maryland State Teachers College in 1934, Salisbury State College in 1963, Salisbury State University in 1988, and finally, Salisbury University in 2001. Today the university serves more than 8,000 students in nearly 60 graduate and undergraduate programs. Its facilities cover some 182 acres. (Courtesy of the Salisbury Area Chamber of Commerce.)

Five

HEALTH CARE

DR. GEORGE TODD. Modern health care in Salisbury can be traced back to Dr. George Todd, who opened the city's first hospital on October 1, 1897, in the converted home of Thomas Mitchell. The building behind Todd in this image is Byrd Tavern, an early Salisbury landmark that once stood at North Division and East Main Streets. The tavern was demolished in 1878.

SALISBURY'S FIRST HOSPITAL. Todd's hospital, seen here, expanded in 1899 with the acquisition of the house next to Mitchell's. It served the community until 1904, when it moved into a new facility at the intersection of South Division and Locust Streets and was renamed Peninsula General Hospital. Todd served as the new facility's superintendent until 1909.

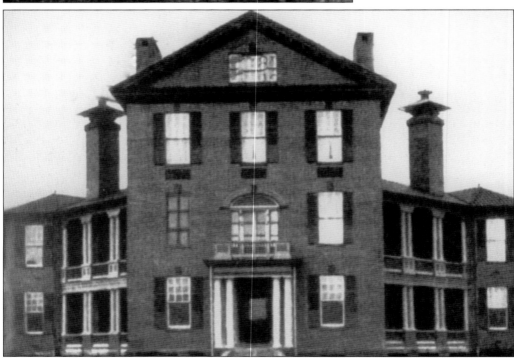

PENINSULA GENERAL HOSPITAL, 1904. The new hospital opened on the grounds that, during the Civil War, held the medical tent for Camp Upton. Local philanthropist and congressman William H. Jackson contributed $50,000 toward the new facility and furnished the building, supplemented by donations from other community members, and water and electricity were provided free of charge by the nearby Jackson Brothers Mill.

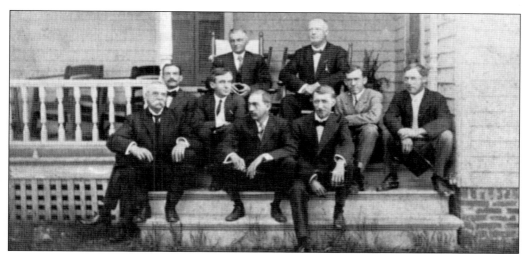

PENINSULA GENERAL HOSPITAL DOCTORS, 1910. The hospital grew rapidly during its early days, with a full contingent of doctors. By 1910, they included, from left to right, (first row) ? Bradshaw, ? Freeny, and ? Morris; (second row) ? Potter, James McFadden Dick, ? Lynch, and ? Elderdice; (third row) George Todd and ? Brotemarkle. Dick was one of the first doctors at Todd's original hospital, working there from 1898 to 1904 and at the new hospital from 1904 until his death in 1939.

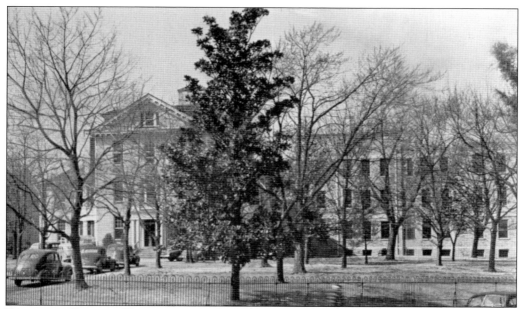

PENINSULA GENERAL HOSPITAL, 1948. In 1940, just in advance of the United States' entry into World War II, a 175-bed north wing opened at the hospital. During the war, Salisbury experienced a shortage of doctors. Many physicians were drafted for military duty, while the ones who were not saw dramatically increased caseloads. Shortly after the war, however, the hospital began to plan for more expansion. (Courtesy of the Salisbury Area Chamber of Commerce.)

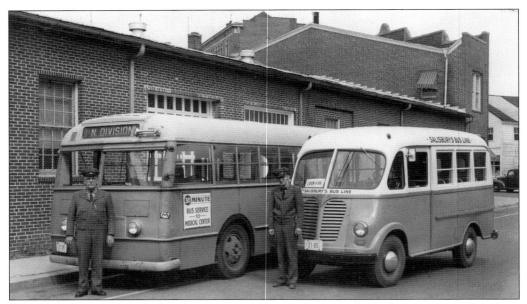

SALISBURY BUS LINE. Ambulance service to the hospital was available almost since its founding. A horse-drawn vehicle served the facility in the early 20th century, replaced by a succession of motorized units beginning in 1919. By the 1950s, bus service was available to the hospital for nonemergencies as Peninsula General became a growing source of health care, not only in Salisbury, but for the Delmarva Peninsula as a whole. (Courtesy of the Salisbury Area Chamber of Commerce.)

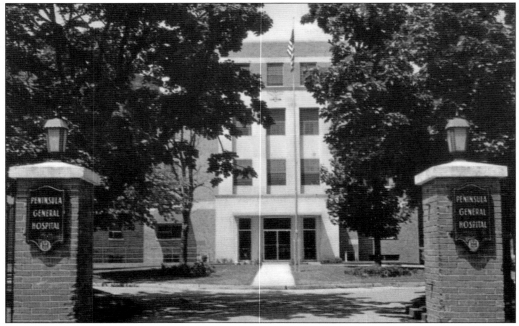

PENINSULA GENERAL HOSPITAL, c. 1965. By the time this photograph was taken, the hospital's capacity had increased to 400 beds and the facility required a full-time staff of 90 to operate. In the years to come, those numbers would skyrocket.

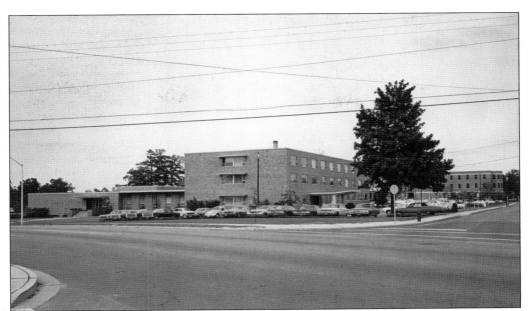

SCHOOL OF NURSING. In 1905, a school of nursing overseen by superintendent of nurses Helen Wise was added to the hospital. Its first graduating class, in 1908, was three women strong. A home for the nurses was built that year. Seen with other auxiliary buildings in this 1968 image, the school closed in 1978 when a nursing program was established at Salisbury State College. (Courtesy of the Salisbury Area Chamber of Commerce.)

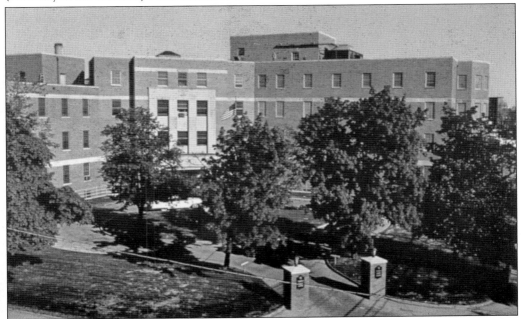

PENINSULA GENERAL HOSPITAL, c. 1970. The hospital underwent two large expansions in less than a decade, starting with the addition of a south wing (left) in 1953. A new east wing (right) followed in 1961. Both are visible in this image. (Courtesy of the Salisbury Area Chamber of Commerce.)

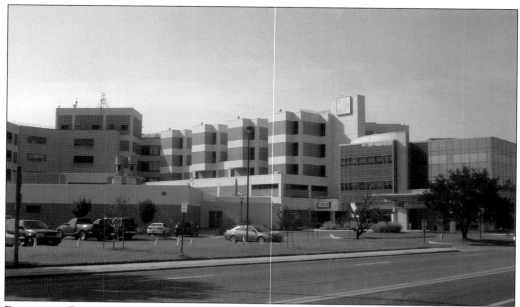

PENINSULA REGIONAL MEDICAL CENTER. The hospital has continued to expand during the past several decades—so much so that it outgrew its own name. In 1992, it was re-branded Peninsula Regional Medical Center, having grown into a full-scale medical center in 1977. It has since added specialized centers, including those for cancer and cardiovascular issues.

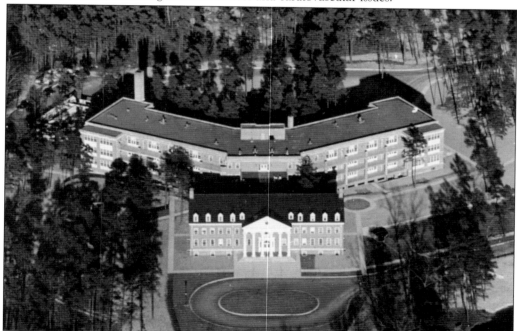

DEER'S HEAD HOSPITAL CENTER. Opened on July 1, 1950, Deer's Head was built as a chronic disease hospital for those with long-term illnesses. Originally constructed to accommodate 284 patients, it has continued to provide services for more than six decades. (Courtesy of the Salisbury Area Chamber of Commerce.)

Six

LANDMARKS

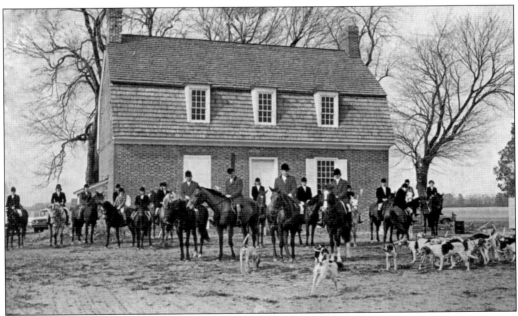

PEMBERTON HALL. Built in 1741 by Col. Issac Handy, Pemberton Hall was constructed on a plantation originally patented by William Stevens in 1679. Handy purchased the plantation from its namesake, Joseph Pemberton, in 1726. Today the restored building is the centerpiece of Pemberton Park, a recreational area encompassing part of the original plantation. The Wicomico Hunt Club, a fox hunting organization, gathered in front of the hall for this *c.* 1966 photograph.

Lt. Joseph Gillis. Salisbury residents at the forefront of the Revolutionary War included Lt. Joseph Gillis, who served as a local militiaman. He had a more personal stake in the war than many. His father, Capt. Thomas Gillis, was one of the five commissioners originally appointed by the Maryland legislature to purchase the land for the settlement of Salisbury. (Courtesy of the Edward H. Nabb Research Center at Salisbury University, Wicomico Historical Society Collection.)

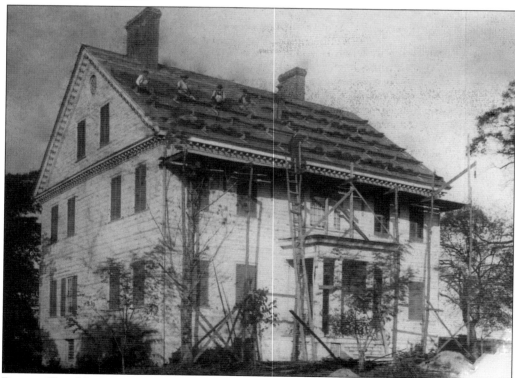

Poplar Hill Mansion. In 1795, Maj. Levin Handy began the construction of Poplar Hill after purchasing part of a land patent known as Pemberton's Good Will; however, illness kept him from completing the building. Dr. John Huston, who purchased the property in 1805, finished the construction. The City of Salisbury has owned the house since 1974. (Courtesy of the Edward H. Nabb Research Center at Salisbury University, Wicomico Historical Society Collection.)

SOMERSET AND WORCESTER BANKNOTE. In the mid-1800s, it was not uncommon for local banks to issue their own currency. Two area institutions known to have done so in Salisbury include the Bank of Salisbury and the Somerset and Worcester Savings Bank, which operated regionally prior to the formation of Wicomico County. These notes, from the latter, were issued during the Civil War in 1862.

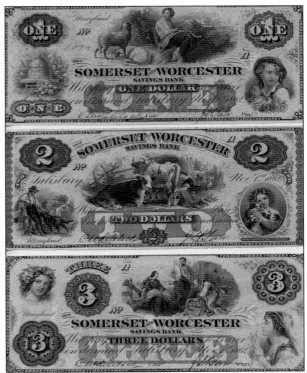

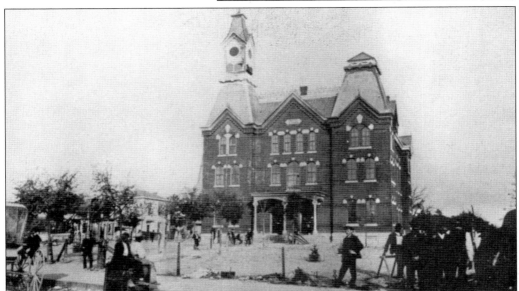

WICOMICO COUNTY COURTHOUSE. Built in 1872, the courthouse remains a landmark in downtown Salisbury. The building was originally constructed to house both the courtroom and county offices. Following a large addition in 1936, the courthouse also became home to the county jail and sheriff's office. Today those services have relocated to buildings of their own in northern Salisbury, and most county offices are housed at the nearby Government Office Building on North Division Street.

WORLD WAR I SOLDIERS. The courthouse served as a backdrop for this gathering of World War I soldiers. While militiamen like Lieutenant Gillis fought to form the United States, they and their predecessors fought to keep it free. (Courtesy of the Edward H. Nabb Research Center at Salisbury University, Wicomico Historical Society Collection.)

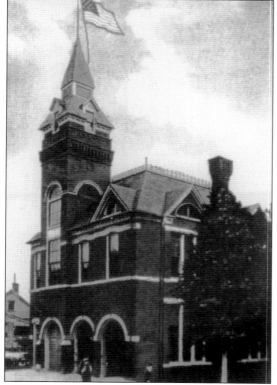

CITY HALL. Built in 1896, city hall served as the headquarters for Salisbury's mayor and city council until the construction of the Government Office Building. Today it remains not only a local landmark, but the symbol of the local revitalization organization Urban Salisbury.

CITY WATER SUPPLY. Seen here in 1896, the standpipe on Lemmon Hill Lane provided Salisbury's water supply for many decades. Erected in 1888, it remained part of the city's landscape as of 2010. (Courtesy of the Edward H. Nabb Research Center at Salisbury University, Wicomico Historical Society Collection.)

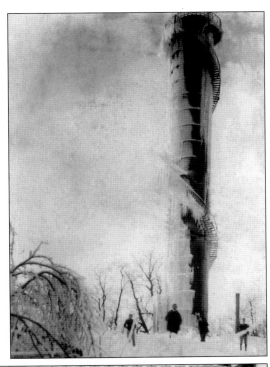

SALISBURY WATER COMPANY. The company that built the standpipe sold stock shares to help pay for its maintenance and upkeep. This 1903 certificate for eight shares identified William Bell as one of the company's early investors. The Salisbury Water Company maintained a business office on Main Street where customers could request service and pay bills.

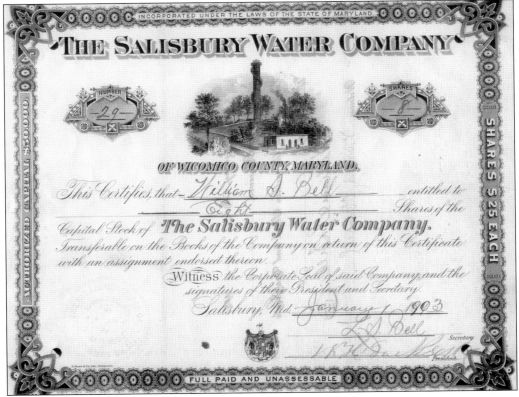

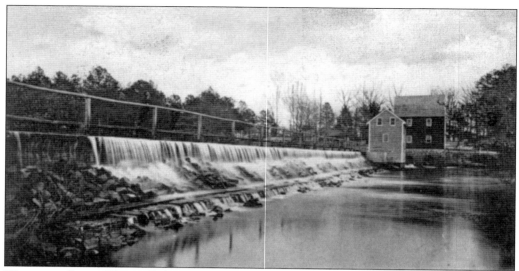

WICOMICO FALLS. The mill dam at Johnson's Pond produced this small waterfall. Known as Tumblin' Dam, the structure featured a small horse path, but was not open to vehicular traffic. (Courtesy of the Salisbury Area Chamber of Commerce.)

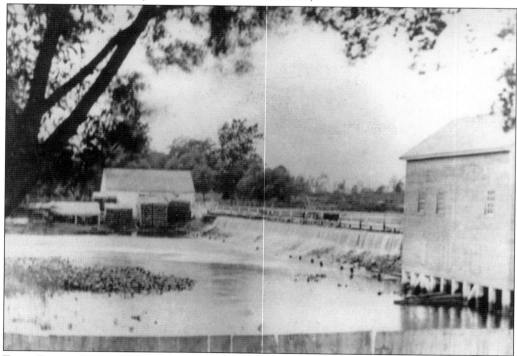

FIRST POWER PLANT UNDER CONSTRUCTION. The Eastern Shore Gas and Electric Company built Salisbury's first power plant on Mill Street at Tumblin' Dam in 1904. On August 10, 1926, the dam broke as the result of massive rainfall caused by a hurricane off the East Coast. Two months later, the company deeded the former dam property and most of Johnson's Lake to the city. (Courtesy of the Edward H. Nabb Research Center at Salisbury University, Wicomico Historical Society Collection.)

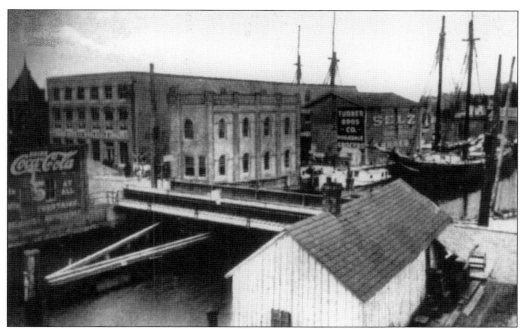

PIVOT BRIDGE, C. 1906. Built to replace the high-arch bridge that once allowed street traffic to cross the Wicomico River at Mill Street while still granting port access to ships, Pivot Bridge remained an important part of Salisbury's landscape until 1926, when it was damaged by a deluge of water caused by the collapse of Tumblin' Dam. Unable to open, the bridge trapped several vessels in port until it could be removed.

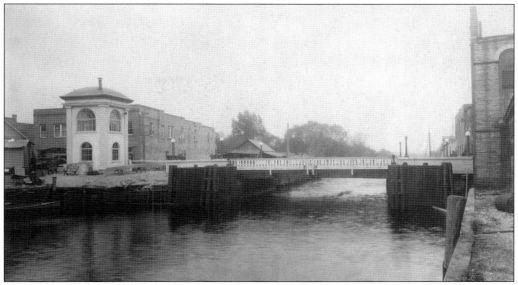

MAIN STREET DRAWBRIDGE. In April 1927, work got underway on a drawbridge to replace Pivot Bridge. The Mount Vernon Bridge Company of Ohio was contracted to construct the new bridge at a cost of $29,554.90, with concrete abutments provided by the Riggin Construction Company of Baltimore. The drawbridge remains in use today. (Courtesy of the Salisbury Area Chamber of Commerce.)

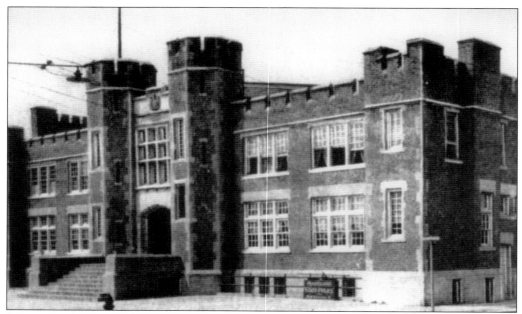

SALISBURY ARMORY. This home of Maryland National Guard Company I was dedicated on Division Street in 1915 as a replacement for the city's first armory on Church Street. The property on which the armory sat was turned over to Wicomico County in 1963 for the creation of the current Wicomico Public Library. A new armory, still in use today, was constructed in northern Salisbury. (Courtesy of the Salisbury Area Chamber of Commerce.)

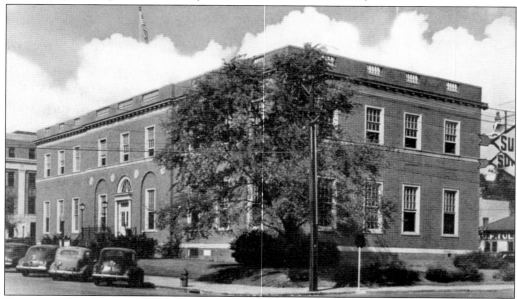

SALISBURY POST OFFICE. Located on East Main Street, the Salisbury Post Office opened in 1925. It was later named the Maude R. Toulson Federal Building in honor of the city's first postmistress. While the building continues to serve as a post office today, it also houses offices for the U.S. Departments of Justice, Commerce, Labor, and Health and Human Services. (Courtesy of the Salisbury Area Chamber of Commerce.)

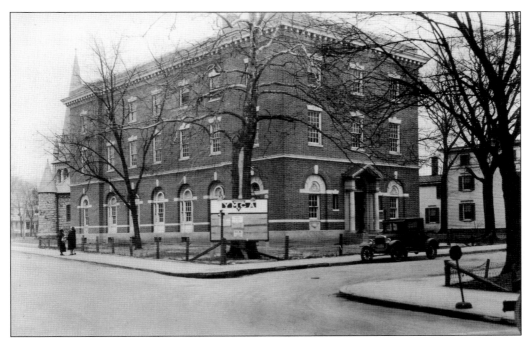

SALISBURY YMCA, C. 1922. Construction of the building housing Salisbury's original chapter of the Young Men's Christian Association was funded by Nannie Rider Jackson in memory of her late husband, Elihu E. Jackson. When the YMCA failed, she turned the North Division Street building over to Trinity Methodist Episcopal Church for use as a Sunday school and meeting hall. (Courtesy of the Salisbury Area Chamber of Commerce.)

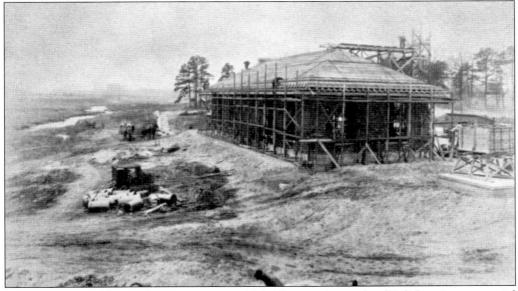

WATER STATION UNDER CONSTRUCTION, 1926. The rapid growth of Salisbury's commercial industry during the first quarter of the 20th century strained its water system. In 1925, the city purchased 52 acres of land reclaimed from Humphreys Lake, issuing a contract that October for construction of a new water plant. (Courtesy of the Salisbury Area Chamber of Commerce.)

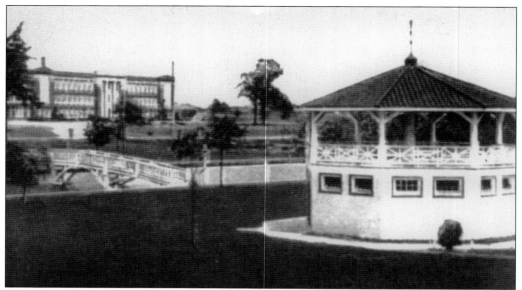

MUNICIPAL PARK. On the remaining property, the city established Municipal Park, alternately called City Park. An illuminated fountain was added to celebrate the city's bicentennial in 1932. Taking advantage of the federal Civil Works, Public Works, and Works Progress Administration programs, city officials from 1933 to 1940 added infrastructure that included trees, bridges, tennis courts, a bandstand, and a man-made peninsula known as Picnic Island. (Courtesy of the Salisbury Area Chamber of Commerce.)

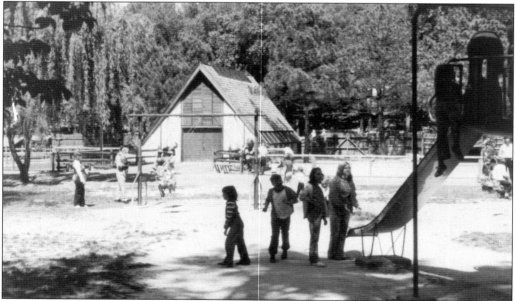

SALISBURY ZOOLOGICAL PARK. Also known as the Salisbury Zoo, this city-owned facility began in 1954, when animals were placed on permanent exhibit in Municipal Park. Improvements in the 1970s created the version of the zoo that stands today. In 2010, the Salisbury Zoological Society began a $3 million public fund-raising drive to finance additional improvements. (Courtesy of the Salisbury Area Chamber of Commerce.)

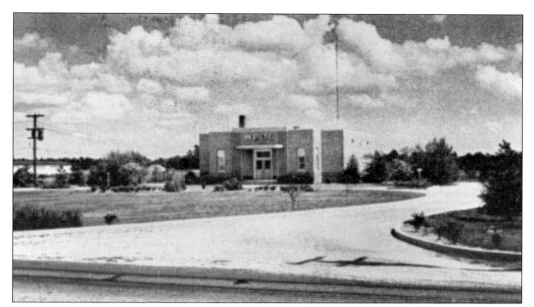

WBOC Radio Station. WBOC began broadcasting on AM frequency 960 on September 13, 1940. Founded by the Peninsula Broadcasting Company, its call letters stood for "between ocean and Chesapeake." A sister FM station followed in 1948. The original building, located on North Salisbury Boulevard, remains today as the headquarters of WBOC TV. (Courtesy of the Salisbury Area Chamber of Commerce.)

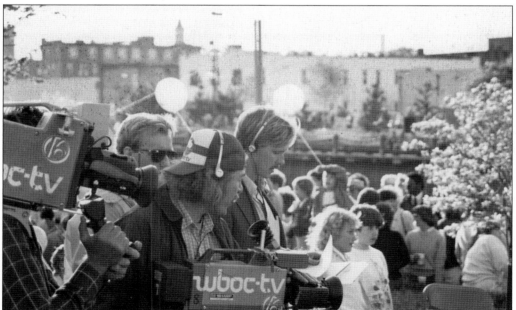

WBOC TV. Represented here at the fifth-annual Salisbury Festival in 1986, WBOC TV began broadcasting on July 15, 1954. It remained a part of the Peninsula Broadcasting Company until it was sold to the A. S. Abell Company, owner of the *Baltimore Sun*, in 1961. Abell sold the station to its current owner, Draper Communications, in 1980, the same year it gained its first local competitor, WMDT TV. (Courtesy of the Salisbury Area Chamber of Commerce.)

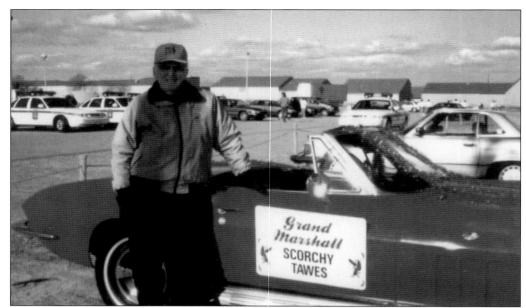

NORRIS "SCORCHY" TAWES. For many years, Scorchy Tawes was considered the "face" of WBOC TV. In 1975, he began hosting the *Outdoor Report* segment on the station's evening newscast, which morphed into the folksier *Scorchy's Corner* in 1977, featuring unique people and traditions. His trademark sign-off, "wandering this Delmarvalous land," became a local catchphrase. Though he retired in 1998, WBOC continued to rebroadcast his segments until his death in 2007. (Courtesy of the Salisbury Jaycees.)

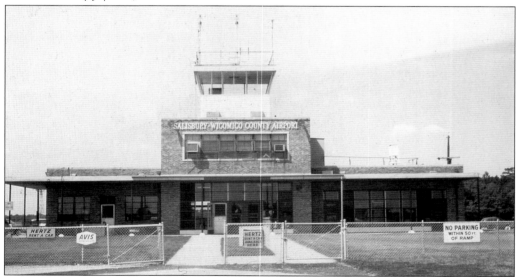

SALISBURY AIRPORT. At the onset of World War II, the U.S. Navy had a pilot training facility built on a former farm just outside Salisbury as a Public Works Administration project. In 1945, Salisbury and Wicomico County jointly acquired the base with the intention of promoting commercial air travel. Today the airport has been renamed the Salisbury–Ocean City–Wicomico Airport to better represent its service to the region. (Courtesy of the Salisbury Area Chamber of Commerce.)

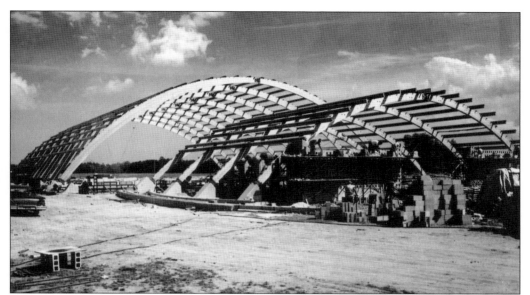

BUILDING THE CIVIC CENTER. Following World War II, the Wicomico County Recreation Commission was established to create recreational opportunities and determine a way to honor veterans. S. Franklin Woodcock donated a parcel of land on Glen Avenue for the cause. More than a decade later, construction of the Wicomico Youth and Civic Center began on that property. (Courtesy of the Edward H. Nabb Research Center at Salisbury University, Wicomico Historical Society Collection.)

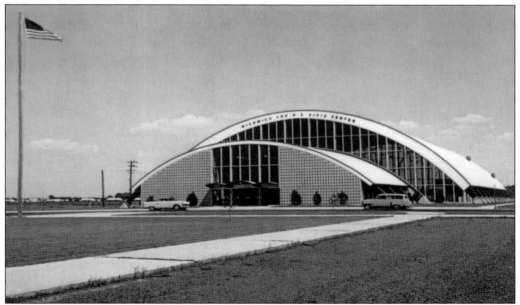

ORIGINAL SALISBURY YOUTH AND CIVIC CENTER. In the 1950s, the county's original recreation commission was reorganized into Maryland's second recreation and parks department, which oversaw the opening of the civic center in 1959. Keeping with the commission's original goal, the civic center was dedicated to area veterans. For the next 18 years, it served as an athletic facility for local youth as well as a site for public events. (Courtesy of the Salisbury Area Chamber of Commerce.)

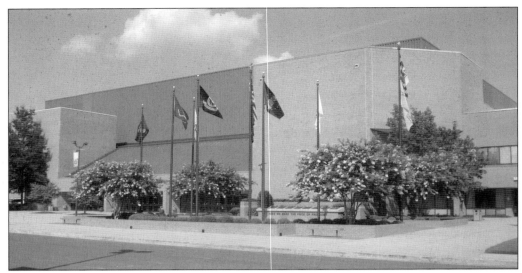

NEW SALISBURY YOUTH AND CIVIC CENTER. After the original civic center was destroyed in a 1977 fire, planning began for a new, more modern structure. The new Wicomico Youth and Civic Center opened at the site of the original in 1980 and continues to serve the community today. In keeping with the original intent of honoring veterans, its meeting rooms are named after the sites of pivotal U.S. military battles, including Normandy and Da Nang.

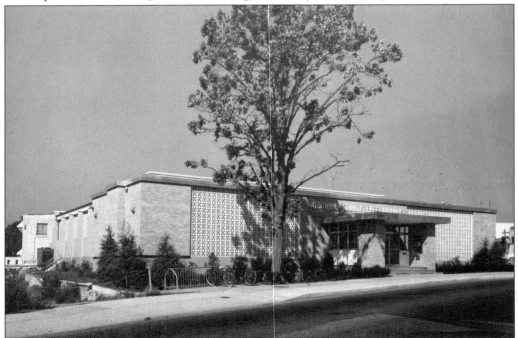

WICOMICO FREE LIBRARY. The Wicomico Public Library system was established as a book subscription service with 30 members in 1869. Following a decreased interest in the early 1900s, it was reestablished in 1916. In 1926, a free public library was established in Salisbury, with a permanent building erected on High Street in 1934. In 1963, the library moved to its current location on Division Street, seen here. (Courtesy of the Salisbury Area Chamber of Commerce.)

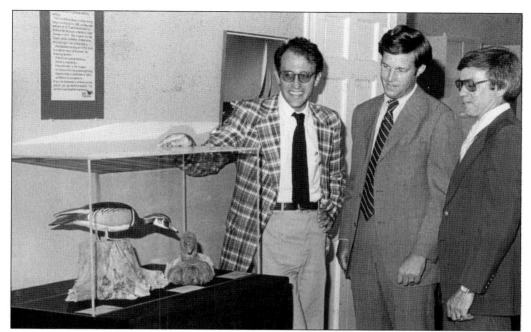

WARD FOUNDATION. This foundation was established in 1968 to preserve the legacy of renowned Eastern Shore decoy carvers Lem and Steve Ward, collectively known as the Ward brothers. In 1975, the foundation partnered with Salisbury State College to create the Ward Museum of Wildfowl Art in Holloway Hall's Great Hall. Pictured from left to right are museum curator Ken Basil, Hugh Mohler, and Tony Middleton. (Courtesy of the Salisbury Area Chamber of Commerce.)

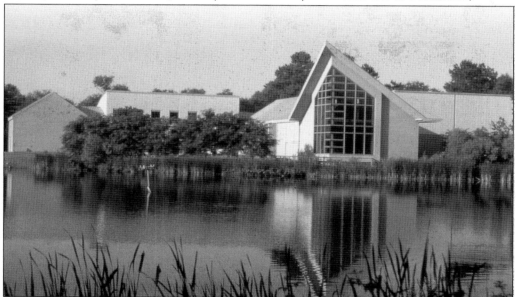

WARD MUSEUM OF WILDFOWL ART. In 1992, the Ward Museum moved into a newly constructed facility on Schumaker Pond in Salisbury. Eight years later, in 2000, the foundation donated the building and its collections to Salisbury State University (formerly Salisbury State College, now Salisbury University), where it became an affiliated organization. (Courtesy of Salisbury University.)

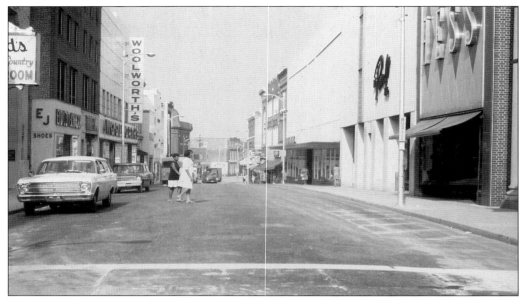

PREPARING FOR A NEW DOWNTOWN. In the late 1960s, the City of Salisbury sought to freshen up its downtown area by converting two blocks of Main Street into a pedestrian plaza. In August 1968, residents had a chance to see this view one last time before construction began. (Courtesy of the Salisbury Area Chamber of Commerce.)

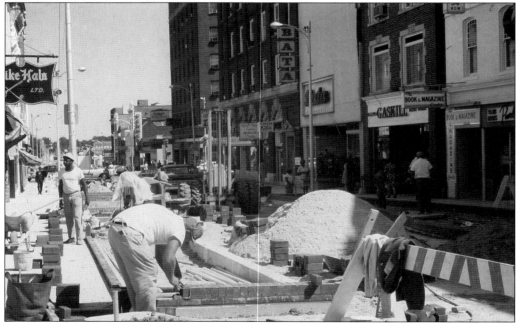

BUILDING THE PLAZA. Construction of the plaza was efficient. Within four months, the old road had been torn out and replaced with the new walkway, which was reminiscent of the early brick road that had been laid at the same location in 1904, years prior to its paving. The main difference this time was that the bricks were red, not yellow like their 1904 counterparts. (Courtesy of the Salisbury Area Chamber of Commerce.)

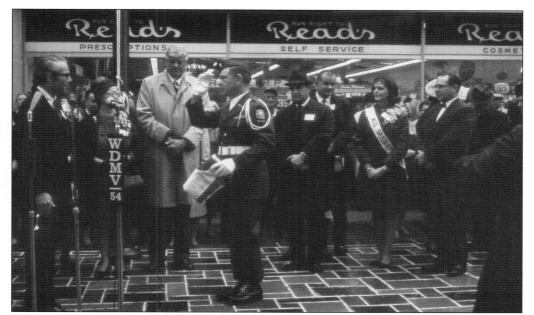

PLAZA DEDICATION. The plaza was dedicated in December 1968. Though appreciated by area merchants, it could not keep the downtown commerce section from eventually eroding as shopping centers and big-box stores with more variety and convenient parking became more plentiful in the city in the 1970s, 1980s, and 1990s. The Read Drug Store, in front of which the ceremony took place, is now home to television station WMDT. (Courtesy of the Salisbury Area Chamber of Commerce.)

CHRISTMAS ON THE PLAZA. The plaza celebrated its first anniversary in 1969 with a festive Christmas display. Stores visible in this view include White and Leonard, Hess Juniors, Kuhn's Jewelers, Mike Hal's, and Edythe's. (Courtesy of the Salisbury Area Chamber of Commerce.)

FRED ADKINS MEMORIAL MONUMENT. Friends of Fred P. Adkins had a modern art sculpture erected in the center of the plaza in memory of the first president of the Salisbury Area Chamber of Commerce in April 1970, at approximately the same location as the large Christmas tree in the image on the preceding page. Adkins died in 1963 at age 75. (Courtesy of the Salisbury Area Chamber of Commerce.)

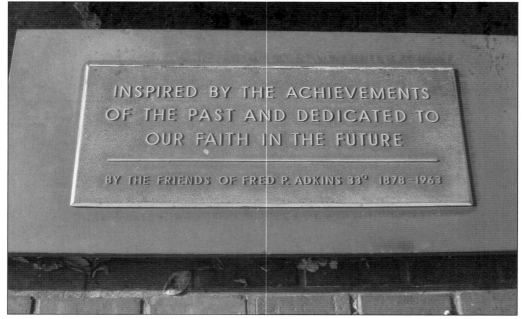

INSPIRED BY THE ACHIEVEMENTS
OF THE PAST AND DEDICATED TO
OUR FAITH IN THE FUTURE

BY THE FRIENDS OF FRED P. ADKINS 33° 1878–1963

MONUMENT INSCRIPTION. The monument and the fountain that surrounds it remain centerpieces of the plaza today. A dedication plaque at the sculpture's base offers an optimistic message.

Seven

COMMERCE

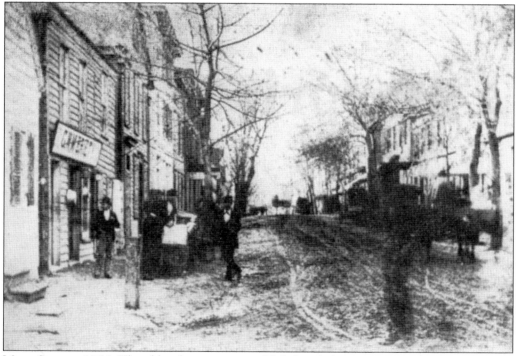

MAIN STREET, 1856. The oldest known image of Salisbury's downtown area shows Main Street as merchants rebuilt it following a devastating fire that destroyed much of the city in 1860. Little did they know that an even larger blaze, the Great Salisbury Fire of 1886, would force them and their successors to rebuild from scratch once again just 30 years after this photograph was taken. (Courtesy of the Salisbury Area Chamber of Commerce.)

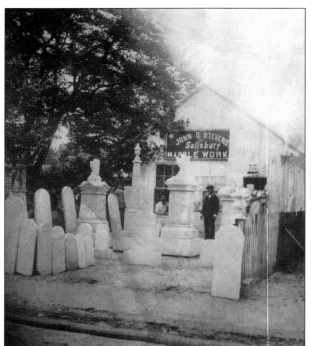

SALISBURY MARBLE WORKS. Located at the intersection of North Division and Broad Streets, this business was owned by John D. Stevens. Destroyed in the Great Fire of 1886, the business was not rebuilt. Today this property is the site of Trinity United Methodist Church. (Courtesy of the Edward H. Nabb Research Center at Salisbury University, Wicomico Historical Society Collection.)

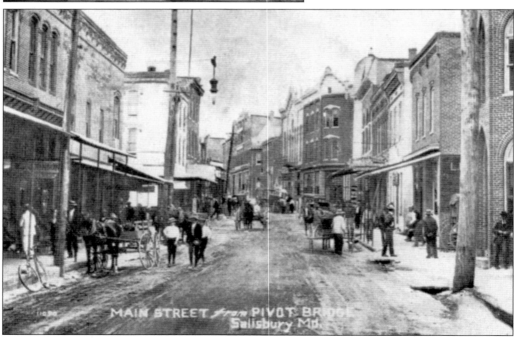

MAIN STREET FROM PIVOT BRIDGE, C. 1903. This view from Pivot Bridge was taken shortly before Main Street was paved with bricks in 1904. Buildings on the left side of the street are, from front to back, Frank Todd's wholesale grocery, Doody Brothers, and the Merchant Hotel. On the right are, from front to back, the Farmers and Planters Company, the Salisbury Candy Company, and the Jackson Brothers Company. (Courtesy of the Salisbury Area Chamber of Commerce.)

ULMAN'S GRAND OPERA HOUSE, 1890. The opera house was an institution in Salisbury for decades and was later converted into a movie theater. The ground floor originally contained a liquor store, which was closed in 1900 and converted into a furniture and variety store. The businesses were founded by brothers Simon and Isaac Ulman.

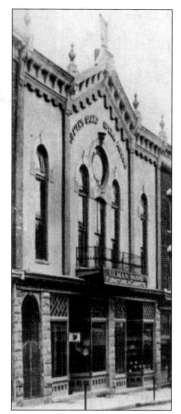

CHRISTMAS AT ULMAN AND SONS, 1911. For children, Ulman's was the place to be at Christmastime, when the store was transformed into a wonderland of toys. The opera house was showing movies by this point. A sign above the store advertises that the films "do everything but talk." (Courtesy of the Edward H. Nabb Research Center at Salisbury University, Wicomico Historical Society Collection.)

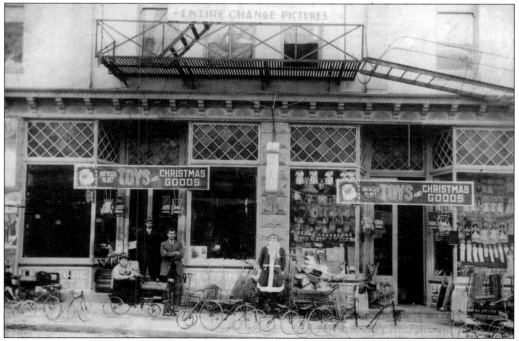

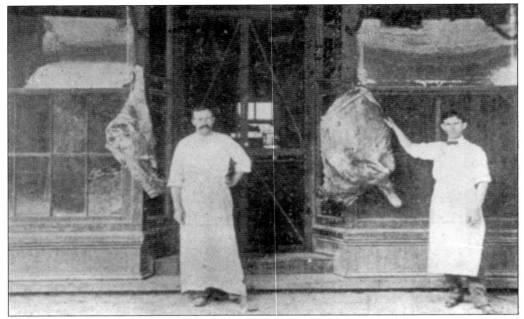

L. S. SHORT. Located on Dock Street (now Market Street), L. S. Short, left, was one of several butchers that served the city in the early 1900s. In this 1908 image, he and an employee showed off some of their prime cuts.

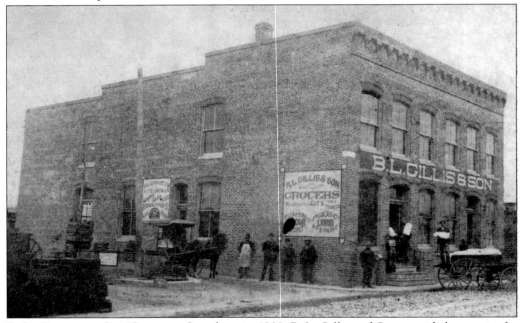

B. L. GILLIS AND SON GROCERY. Seen here in 1900, B. L. Gillis and Son provided groceries for city residents in the early 20th century. A sign on the side of the building advertised another business, Humphreys and Tilghman, whose retail holdings included hay, grain, and moldings. (Courtesy of the Edward H. Nabb Research Center at Salisbury University, Wicomico Historical Society Collection.)

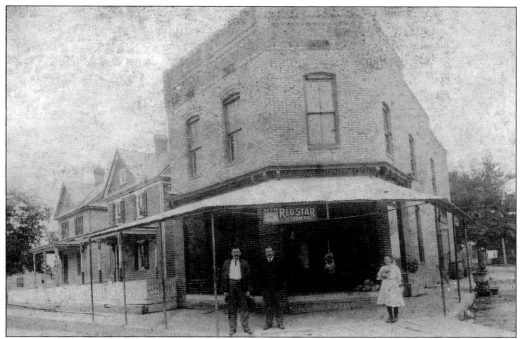

HITCH GROCERY. Brothers Ernest B. (left) and Herbert H. Hitch (right) ran another popular grocery store in the city at the start of the 20th century. Herbert was a high-profile businessman and served on the city council in the early 1900s. The store remained in business at West Main Street and Delaware Avenue at least until 1930. (Courtesy of the Edward H. Nabb Research Center at Salisbury University, Wicomico Historical Society Collection.)

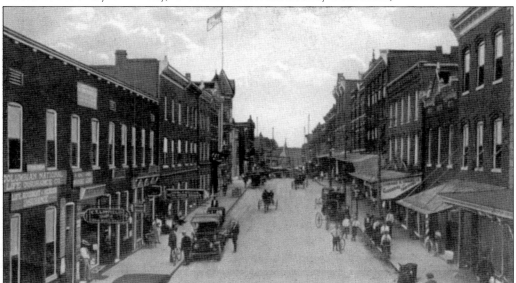

MAIN STREET, C. 1908. The building on the left in this image provided two opportunities to purchase insurance, serving as offices for the Columbian National Life Insurance Company and insurance agent William S. Gordy. In the center of the row of businesses on the right side is the store of Leonard H. Higgins, who sold men's clothing.

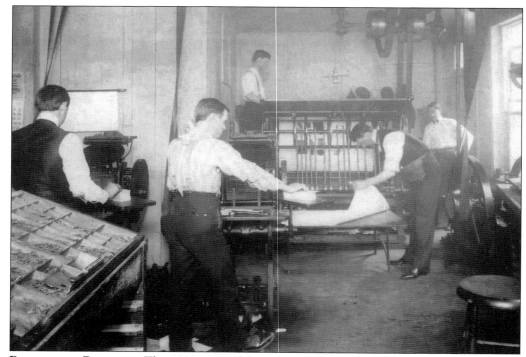

BREWINGTON BROTHERS. This 1920s view of the Brewington Brothers Company shows a selection of the printing business's staff. Pictured are, from left to right, two unidentified, Syd Dougherty, Marion Brewington, and Walter Brewington. The company printed the *Wicomico News* as well as local flyers and programs and state governmental reports. (Courtesy of the Edward H. Nabb Research Center at Salisbury University, Wicomico Historical Society Collection.)

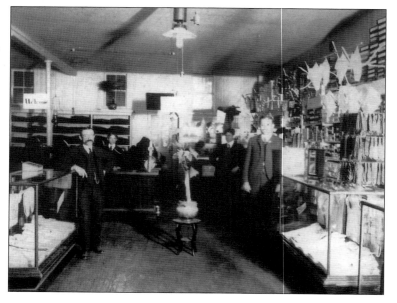

KENNERLY AND MITCHELL STORE. B. Frank Kennerly and Ned Mitchell were the proprietors of this downtown clothing shop, which closed in the 1940s. Pictured are, from left to right, Kennerly, Claude Dayton, Charlie Bennett, and Mitchell. (Courtesy of the Edward H. Nabb Research Center at Salisbury University, Wicomico Historical Society Collection.)

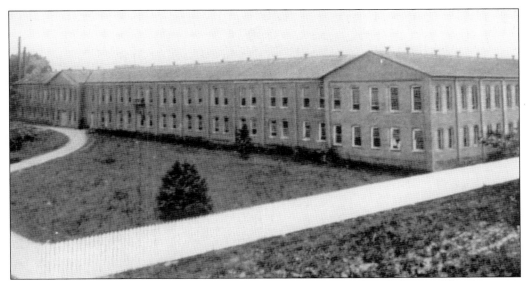

JACKSON AND WEISBACH COMPANY. William Purnell Jackson cofounded several businesses in Salisbury, including W. H. Jackson and Son Lumber Mill; Jackson Brothers Company, a lumber mill and retail store co-op; the Home Gas Company; the Salisbury Ice Company; and in the early 1900s, the Jackson and Weisbach shirt manufacturing company. (Courtesy of the Edward H. Nabb Research Center at Salisbury University, Wicomico Historical Society Collection.)

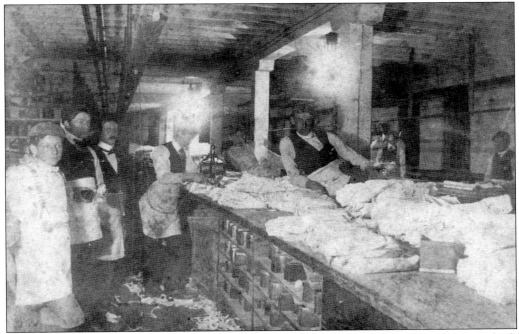

INSIDE JACKSON AND WEISBACH. This rare view shows the early days of the shirt factory, which was also known as Jackson and Gutman or Jackson, Gutman, and Lane, depending on who was managing the business at the time. In addition to his own enterprises, Jackson was president of the Salisbury National Bank and Peninsula General Hospital. He also served for a short time on the Salisbury City Council. (Courtesy of Etta Lokey.)

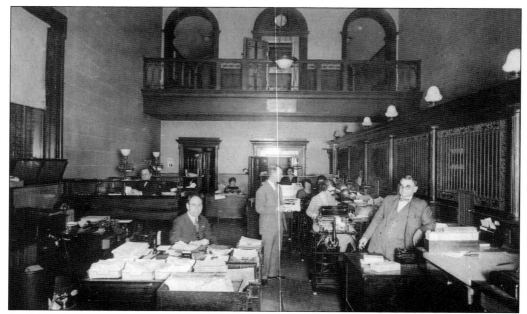

SALISBURY NATIONAL BANK. Pictured in the foreground are, from left to right, L. Walter Crock, L. A. Holloway, R. H. H. Ruark, unidentified, and R. E. C. Fulton. In 1930, the bank moved across the street from its original Main Street location. It later merged with the First National Bank of Maryland, now M&T Bank. (Courtesy of the Edward H. Nabb Research Center at Salisbury University, Wicomico Historical Society Collection.)

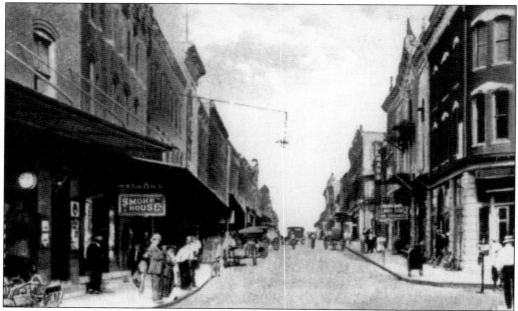

FIRST ELECTRICAL SIGN. The "Smoke House" portion of the sign at Watson's Smoke House, seen in this 1910 image, is believed to have been the first electrical sign in Salisbury. Adjoining businesses include jeweler George Phipps and the Surprise Store, housed in what at that time was Salisbury's tallest building.

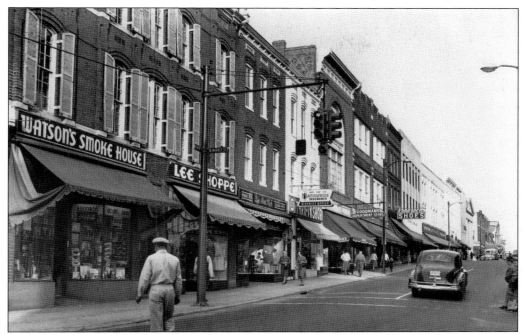

WATSON'S SMOKE HOUSE, C. 1950. Founded in 1896, Watson's stood the test of time in downtown Salisbury. The tobacco shop later added a soda fountain and, in the 1950s, began selling records. The store had upgraded to cassettes by the time it finally closed after serving as a city landmark for the better part of a century. (Courtesy of the Salisbury Area Chamber of Commerce.)

LUMBER MILL, C. 1910. Mills like this were common throughout Salisbury and Wicomico County from the mid-1800s through the early 1900s. It is thought that this might be one of the William Jackson mills. (Courtesy of Etta Lokey.)

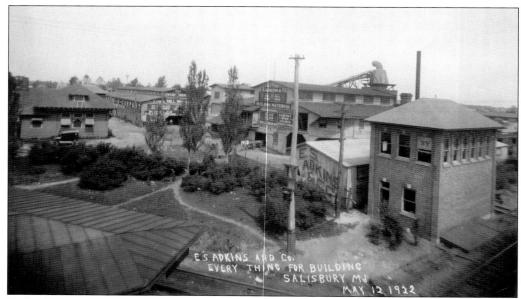

E. S. Adkins and Company. Elijah Stanton Adkins formed this lumber company near the convergence of two rail lines in Salisbury in 1893 after learning the business from his father, who operated a sawmill in nearby Powellville. By 1963, the company had branched out, opening a do-it-yourself home project store. The business, seen here in 1922, continues today. (Courtesy of the Salisbury Area Chamber of Commerce.)

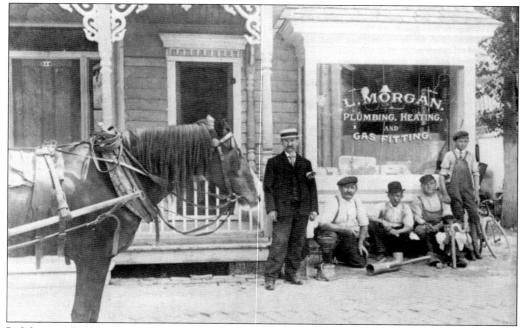

L. Morgan Plumbing. Of course, not every home repair or upgrade is a do-it-yourself project. That is where early companies like L. Morgan Plumbing, Heating and Gas Fitting, located on Church Street, came in. Gas was first used as a fuel source for lights in Salisbury in 1907. (Courtesy of the Salisbury Area Chamber of Commerce.)

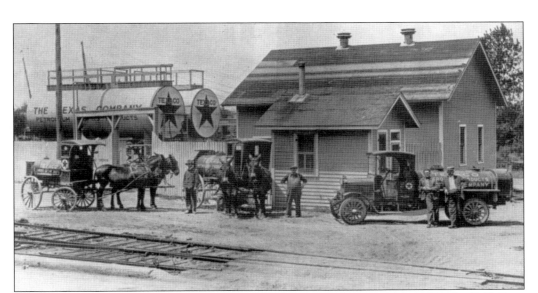

TEXACO PLANT. Gas and oil have long been big business in Salisbury. About 1927, the E. T. Cato Company became a local distributor for Texaco petroleum products, supplying gas and oil to power and heat area homes. (Courtesy of the Salisbury Area Chamber of Commerce.)

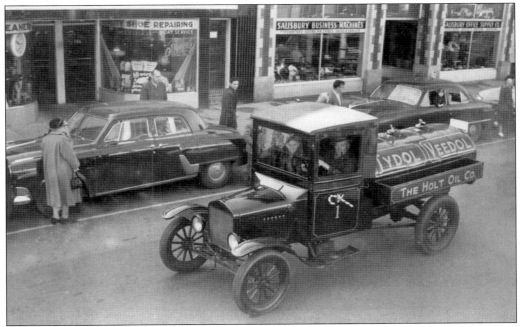

HOLT OIL COMPANY. One of Cato's competitors in the city, Holt Oil Company, decorated its delivery truck for Christmas when this 1930s photograph was taken on Main Street. In the background is the Salisbury Business Machine and Supply Company, specializing in typewriters and adding machines. (Courtesy of the Salisbury Area Chamber of Commerce.)

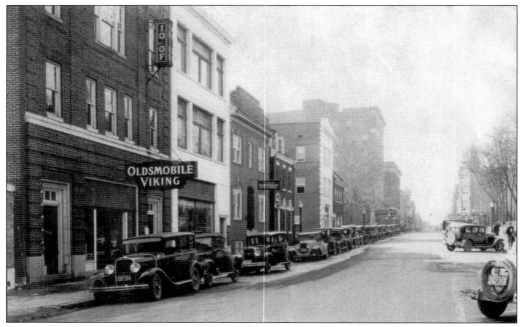

OLDSMOBILE VIKING. As with most cities, Salisbury's transportation preference moved from horses and bicycles to cars during the early 20th century. A sign advertising the Oldsmobile Viking dates this photograph of Salisbury's International Order of Odd Fellows meeting hall to 1929 or 1930, the only two years the car was produced. The Salisbury chapter of the Odd Fellows dissolved in 1942. (Courtesy of the Salisbury Area Chamber of Commerce.)

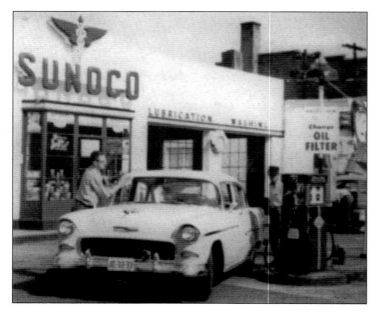

SCOTT'S SUNOCO SERVICE. Gas stations like Scott's Sunoco Service, located at the intersection of Main and Baptist Streets when this photograph was taken in 1957, helped keep Oldsmobiles and many other cars running. According to an advertisement from that year, Scott's offered lubrication, washing, simonizing, tune-ups, brake and muffler service, tubeless tire service, and "premium gas at regular price." (Courtesy of Salisbury University.)

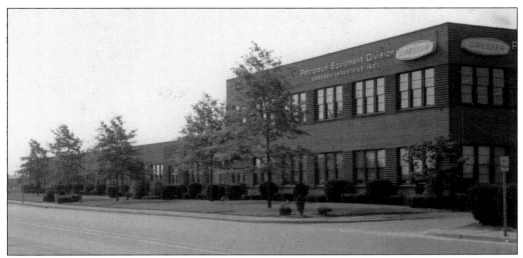

DRESSER WAYNE. Founded in Buffalo, New York, in 1922, the Martin and Schwartz Pump Company moved its headquarters to Salisbury in 1939. In 1951, the Wayne Pump Company purchased Martin and Schwartz and relocated its national headquarters to Salisbury. Dresser Industries acquired the business in 1968, forming Dresser Wayne. The gas pump manufacturer was one of the city's largest employers until it closed its Salisbury plant in 2001. (Courtesy of the Salisbury Area Chamber of Commerce.)

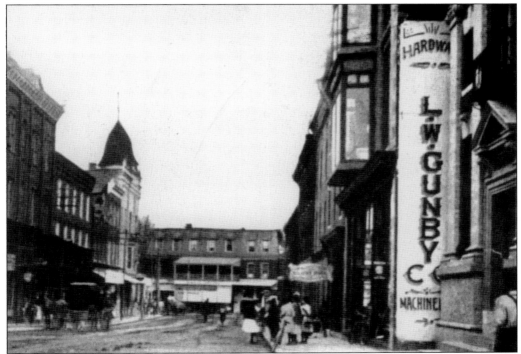

L. W. GUNBY HARDWARE. Louis White Gunby opened his hardware store in Salisbury in 1872. Business was so successful that he moved to this larger Main Street location in 1887 and, by 1901, had added a shipping and receiving annex near the city's New York, Pennsylvania, and Norfolk Railroad freight station. The company celebrated its 100th anniversary in 1972.

DORMAN AND SMYTHE HARDWARE. Local businessman Levin W. Dorman built this 12,000-square-foot building on Main Street in 1886 to house his hardware company. His business partner, Smythe, was with the company for only a short time. The store found success, but, like many others, could not compete with the economic pressures of the Great Depression and closed its doors in the 1930s.

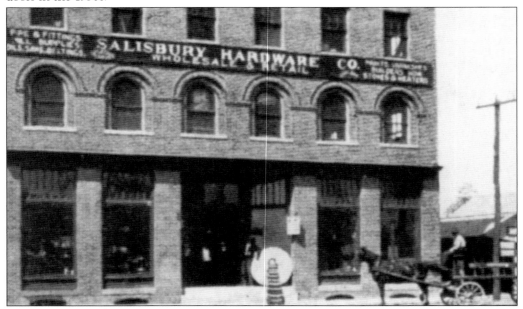

SALISBURY HARDWARE. Another early hardware store, the Salisbury Hardware Company, was established at the convergence of Church and William Streets and Railroad Avenue. Its location near Salisbury's passenger train station made it an easy stop for those coming into the area from surrounding communities or returning home from a visit elsewhere.

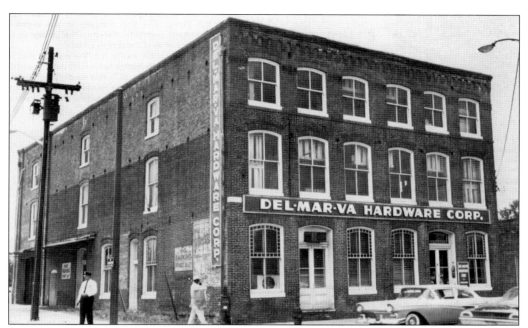

Del-Mar-Va Hardware. A later hardware company, the Del-Mar-Va Hardware Corporation, served area residents when this 1950s photograph was taken. Chain hardware stores moving into the area in the latter half of the 20th century drove many local proprietors out of business. (Courtesy of the Salisbury Area Chamber of Commerce.)

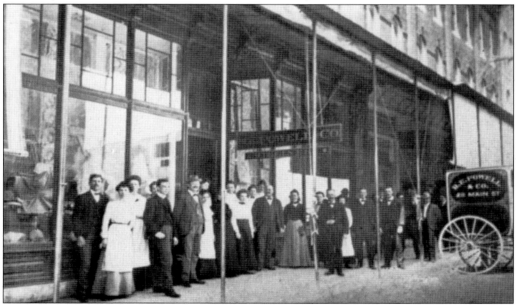

R. E. Powell and Company. Like many of Salisbury's early businessmen, R. E. Powell owned several companies in the city, including a clothing store, seen here, and a furniture store. The clothier celebrated its 100th anniversary in 1967. The address on the delivery wagon at right, 211 Main Street, dates this photograph prior to 1909, when the street was extended and divided into east and west sections. (Courtesy of the Salisbury Area Chamber of Commerce.)

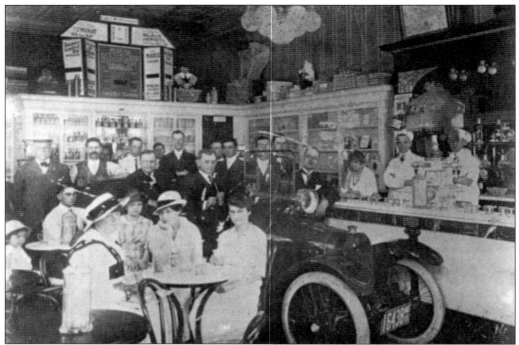

Burris Drug Company, 1915. This store was located at West Main and Market Streets. Pictured are, from left to right, (first row) Kathryn Perdue, Weldon "Chick" Fooks, Elizabeth Hagan Smith, Dorothy Perdue, Mame Truitt Russell, and Madelyn Tull Stone; (second row) unidentified, Guy Mandanici, unidentified, Dr. A. B. Burris, Charles Bennett, Dr. Ferris Belt, Dr. William J. Holloway, four unidentified, Arthur "Shiner" Leonard, Lydia Disharoon, Arthur "Happy" Ward, and Dr. Albin A. Hayman.

Wicomico News. In 1886, A. Lee Lankford established the *Wicomico News*, one of 14 newspapers to have served the city between 1859 and today. In 1887, Marion and Harry Brewington purchased the newspaper and ran it for 31 years, selling it to publisher Fred P. Adkins in 1918. It continued publication until 1938, when it became part of the *Salisbury Times*. Its downtown office was later refurbished into retail space. (Courtesy of the Salisbury Area Chamber of Commerce.)

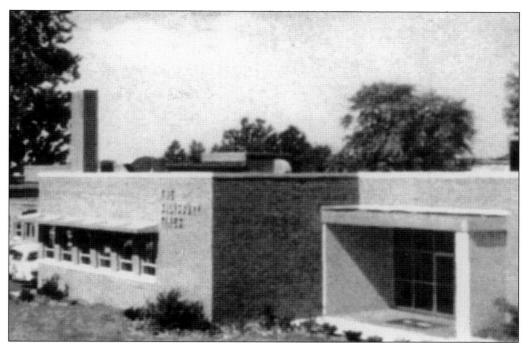

SALISBURY TIMES. On December 3, 1923, Adkins published the first edition of the *Evening Times*, renamed the *Salisbury Times* in 1927. Today operating as the *Daily Times*, it is the last surviving newspaper out of the 14 that have served Salisbury since 1859. For many years, its office was located in the building seen here, at the former site of Camp Upton, before moving to a business park in northern Salisbury in 2007.

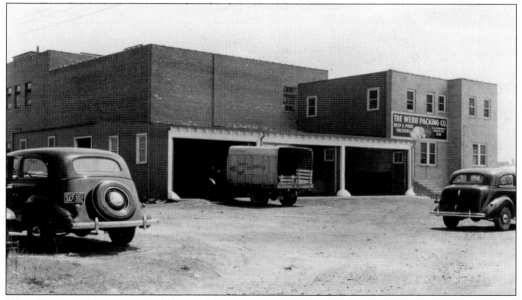

WEBB PACKING COMPANY. Webb was a big name in meat products throughout the region during the first half of the 20th century. Its Salisbury packing plant—one of several throughout the Eastern Shore—is seen here around 1950. (Courtesy of the Salisbury Area Chamber of Commerce.)

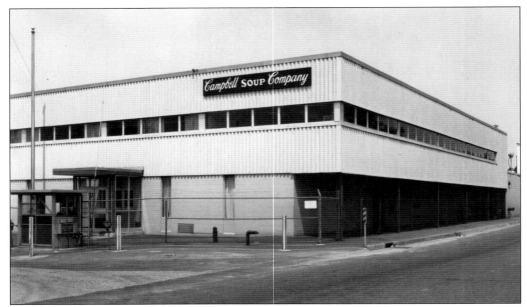

CAMPBELL SOUP COMPANY. This frozen food processing plant opened in Salisbury in 1945 as part of the Jerpe Commission Company, later C. A. Swanson and Sons. The Campbell Soup Company acquired Swanson in 1955, and the plant operated under the Campbell name for the next 38 years. When it closed in 1993, it was one of the city's largest employers, with a work force of over 800. (Courtesy of the Salisbury Area Chamber of Commerce.)

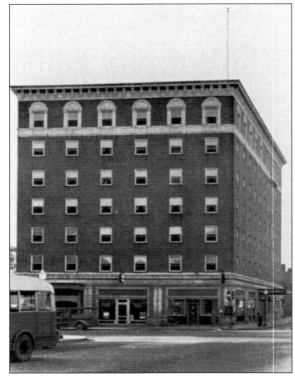

WICOMICO HOTEL, c. 1945. In 1923, the Salisbury Area Chamber of Commerce, formed only three years prior, optioned a parcel of land at the intersection of Main and Division Streets and began selling stock for a new $250,000 hotel it hoped would attract potential customers to the city. The result, the Wicomico Hotel, opened on October 14, 1924. (Courtesy of the Salisbury Area Chamber of Commerce.)

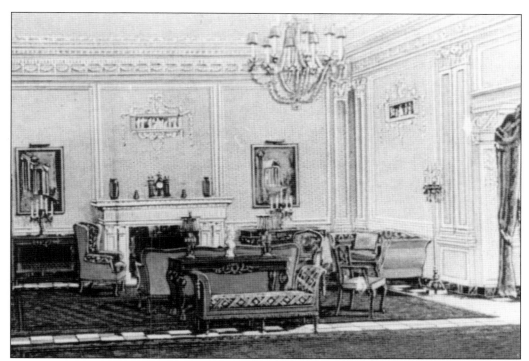

Wicomico Hotel Lobby, c. 1925. The hotel's ornate lobby served as a gathering spot for guests as well as local businessmen. When the city's downtown section began losing its luster as a commercial district, the hotel went with it, closing in the 1970s. Today the building contains the One Plaza East office complex. (Courtesy of the Edward H. Nabb Research Center at Salisbury University, Wicomico Historical Society Collection.)

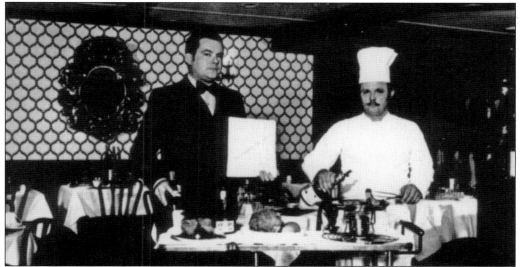

Continental Café, 1972. Jean Pierre Bouvier and Jack Curtis posed for this publicity photograph for the hotel's Continental Café. Once the hotel closed, the restaurant reopened as Chez Jean Pierre. (Courtesy of the Edward H. Nabb Research Center at Salisbury University, Wicomico Historical Society Collection.)

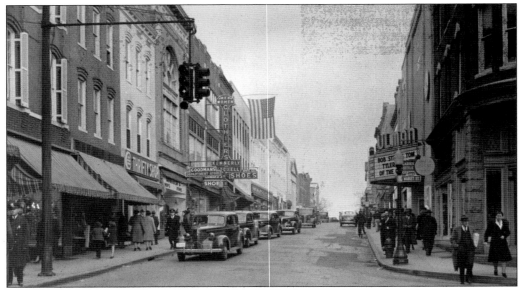

MAIN STREET. Downtown was busy when this 1940s photograph was taken. At the far left is the Lee Shoppe clothing store, followed by the Thrifty Shop, Goodman Department Store, Kennerly and Mitchell, and E. Homer White Company shoe store, with the Smith Dress Shop across the road at Market Street. The Ulman Theater is showing the 1942 Western *Code of the Outlaw*. (Courtesy of the Salisbury Area Chamber of Commerce.)

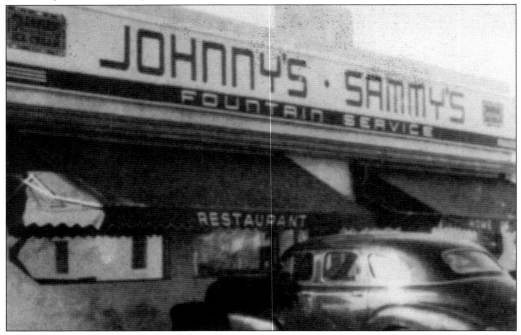

JOHNNY'S AND SAMMY'S, 1948. Seen here just two years after its opening in 1946, Johnny's and Sammy's was for decades Salisbury's premier dining spot. Located on South Salisbury Boulevard, the restaurant was owned by Johnny Testa and Sammy Cerniglia. (Courtesy of Salisbury University.)

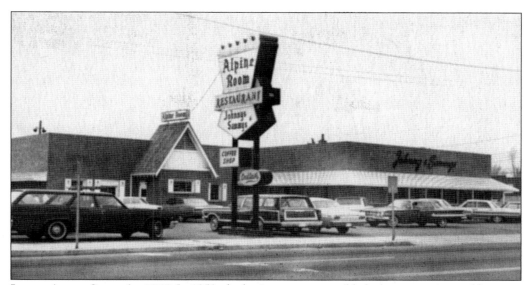

JOHNNY'S AND SAMMY'S, 1967. In 1950, the business partners added a large meeting and banquet facility, the Mid-Ocean Room, which served many local civic clubs and large parties. It was later converted into a fine-dining facility and renamed the Alpine Room, seen here. In later years, the building housed several other restaurants before being demolished in the late 1990s to make way for a Wawa gas station.

POLAR BAR. Seen here in 1957, the Polar Bar on East Main Street was another popular restaurant in Salisbury, famous for its ice cream and handmade doughnuts. In the early 21st century, another local restaurant, DeVage's Subs, moved from its College Avenue location into the long-abandoned Polar Bar building, bringing back the original doughnuts that made the Polar Bar famous. (Courtesy of Salisbury University.)

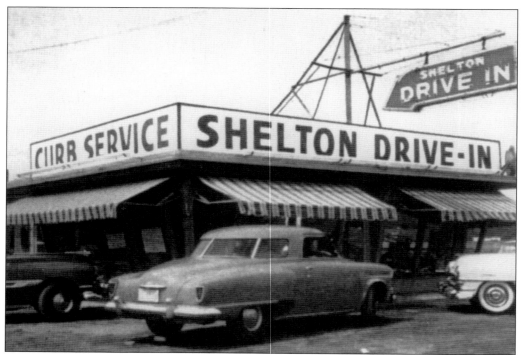

SHELTON DRIVE-IN. Located on North Salisbury Boulevard, this drvie-in restaurant was owned and operated by Christian Shelton and offered breakfast, lunch, and dinner. It closed in the early 1960s. The building was torn down, and the grounds have become part of Salisbury's retail corridor.

OAKS DRIVE-IN. One of the most popular teenage hangouts of 1950s and 1960s Salisbury was the Oaks Drive-In on South Salisbury Boulevard. Owned and operated by Hermus W. Lowe, the Oaks rarely had enough parking for all its potential customers, with many circling the lot for up to a half hour before finding a spot. Today a branch of PNC Bank stands at its former location. (Courtesy of the Salisbury Area Chamber of Commerce.)

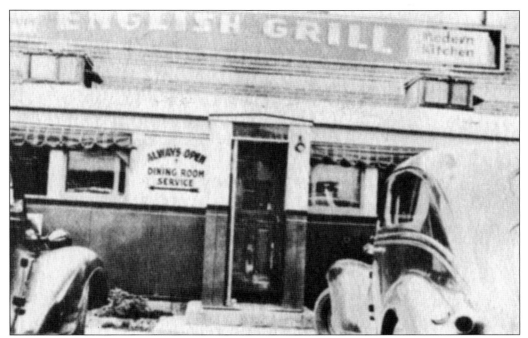

ENGLISH GRILL. When James English Sr. opened his first restaurant on Salisbury's Main Street in 1933, he likely had little idea of the culinary impact he would make on the Eastern Shore. By the end of the 20th century, English's fried chicken restaurants were a hallmark of communities throughout the region. One by one, they closed in the late 1990s and early 2000s, and today only one, in Ocean City, Maryland, remains.

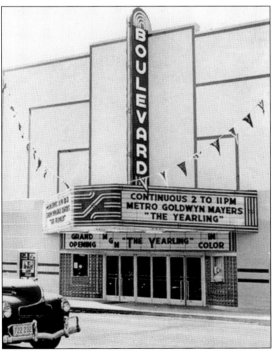

BOULEVARD THEATER. Salisbury's popular Boulevard Theater opened at East Main Street and North Salisbury Boulevard in June 1947 with a showing of *The Yearling*. Designed by Newell Howard and Raymond Todd for the Ulman Theater Corporation, it opened as the Eastern Shore's largest movie palace, with seating for 1,105. It was later divided into six separate auditoriums and renamed Movies 6. It ended its life as a second-run theater in 2000 and was demolished in 2008.

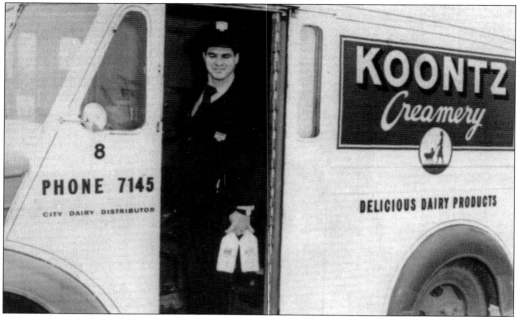

CITY DAIRY TRUCK, 1955. The first dairies in Salisbury sprang up during the early 1900s. About 1940, City Dairy joined several others in providing service to the area. It later became a branch of the Baltimore-based Koontz Creamery, offering products including chocolate milk, buttermilk, eggs, cottage cheese, cream, and sour cream. (Courtesy of Salisbury University.)

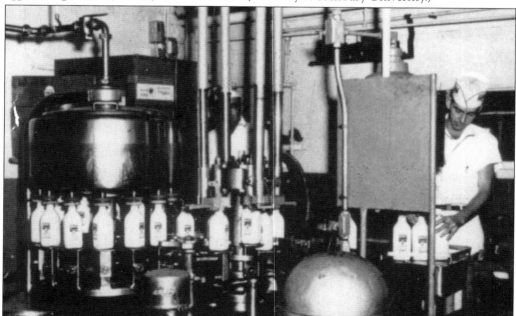

INSIDE CITY DAIRY. The dairy's pasteurizing and filling plant was considered state of the art when this photograph was taken in 1957. Today all that is left of the once-prosperous business is the applied-color-label milk bottles, like those seen in this image, that occasionally appear for sale at local antique stores and on Internet auction sites. (Courtesy of Salisbury University.)

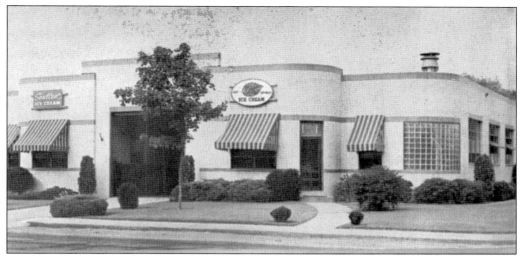

CITY DAIRY. In 1922, the Peninsula Ice Cream Company was incorporated in Salisbury at a cost of $25,000, with H. W. Ruark serving as company president. By the time this photograph was taken, around 1967, City Dairy had taken over as the area's major ice cream distributor, serving as a local agent for Sealtest products, including milk and ice cream, as well as Breyer's ice cream.

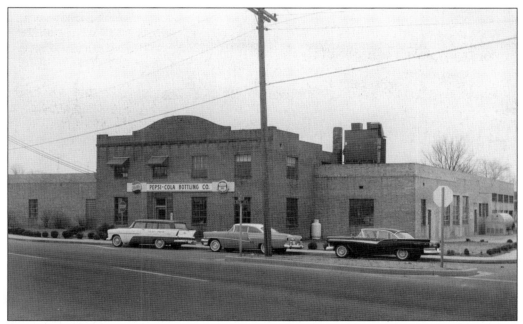

PENINSULA BOTTLING COMPANY. In 1915, Lewis Morgan established the Peninsula Bottling Company and was soon contracted to bottle Pepsi-Cola. By the time this 1950s photograph was taken, the business's name had changed to the Pepsi-Cola Bottling Company to reflect its star product. Today the company operates as Pepsi Bottling Ventures of Delmarva at a newer facility in northern Salisbury. (Courtesy of the Salisbury Area Chamber of Commerce.)

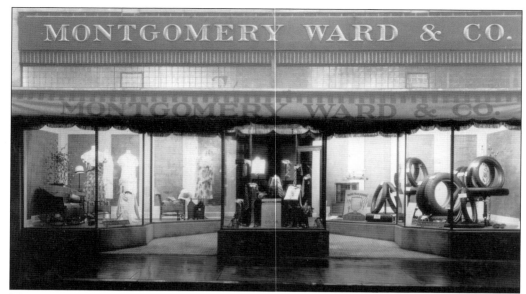

MONTGOMERY WARD AND COMPANY. The former retail giant had a long history in Salisbury, beginning with the downtown franchise seen here. Later the store relocated to a larger facility at South and South Salisbury Boulevards. In the early 1990s, it gave up that location to serve as an anchor store at the new Centre at Salisbury mall. The chain went out of business in 2001. (Courtesy of the Salisbury Area Chamber of Commerce.)

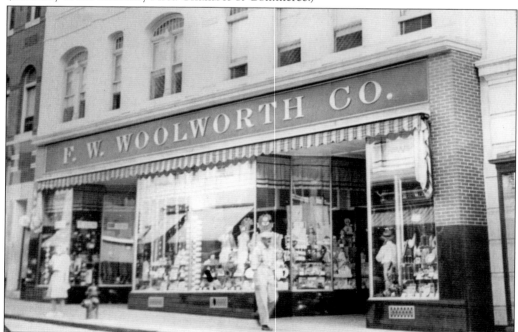

WOOLWORTH'S. Like many communities in the mid-20th century, Salisbury had its own F. W. Woolworth department store on Main Street. Seen here in the 1960s, it eventually became a casualty of the changing tastes that drew shoppers away from the downtown area and into shopping centers and big-box stores. (Courtesy of the Salisbury Area Chamber of Commerce.)

MAIN STREET, C. 1955. Stores in this view of downtown Salisbury include, from left to right, Bata shoes, Ralph and Gaskill men's clothing, the Mayflower Grill, Trabin's yard goods and drapery, and Household Finance Loans. (Courtesy of the Salisbury Area Chamber of Commerce.)

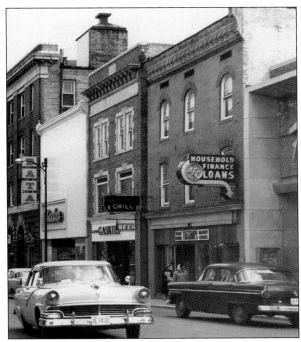

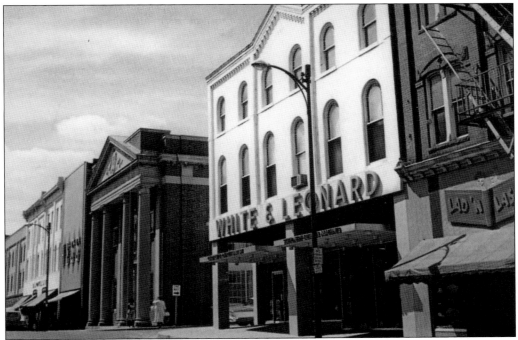

WHITE AND LEONARD, C. 1965. Founded as a pharmacy by James Leonard and Ted White, this popular Main Street fixture ended its life as a stationery and furniture store. At its right is the children's clothing store Lad 'n Lassie. To its left, from front to back, are the Salisbury National Bank, Hess shoes, R. E. Powell's clothing, McCrory's five and dime, Benjamin's clothing, and Goodman's Department Store. All are gone today.

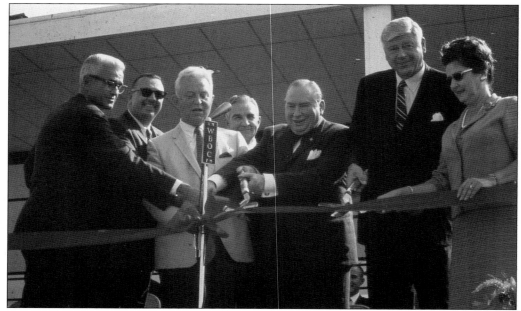

SALISBURY MALL GRAND OPENING. Shopping habits changed dramatically in Salisbury beginning with the opening of the 600,000-square-foot Salisbury Mall in 1968. Local and state elected officials joined investors for a ribbon-cutting ceremony to mark the new shopping outlet's grand opening. It did not take long for the mall to become a powerhouse retail location and a popular meeting spot for residents throughout the Eastern Shore. (Courtesy of the Salisbury Area Chamber of Commerce.)

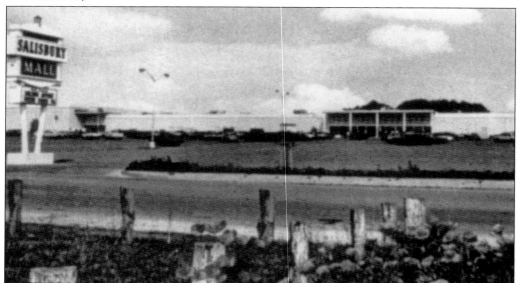

SALISBURY MALL. However, that popularity did not last. A newer mall, the Centre at Salisbury, opened on July 27, 1990, in northern Salisbury. Many of the Salisbury Mall's most prominent stores fled to the new facility, taking their customers with them. After hobbling along for the next 14 years, its tenants consisting mostly of antiques shops and second-hand stores, the old mall closed in 2004 and was razed in 2008.

Eight

AGRICULTURE

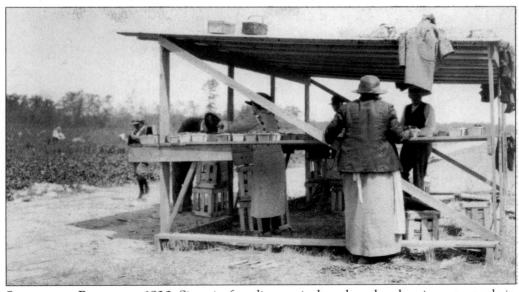

STRAWBERRY PICKERS, C. 1930. Since its founding, agriculture has played an important role in Salisbury. Workers picking strawberries for booths like this one would be paid in tickets denoting how many quarts they had turned in. Tickets could be turned in for cash at the end of the day or, at some stores, used as currency. (Courtesy of the Salisbury Area Chamber of Commerce.)

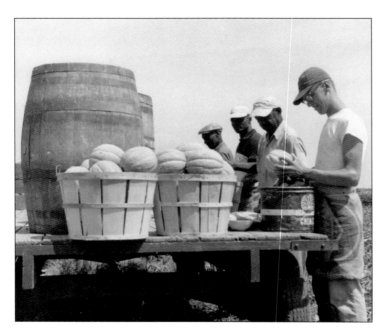

INSPECTING CANTALOUPES. At most local farms, produce was inspected before making its way to the marketplace. Once trucks were loaded, vegetables and fruits, like these cantaloupes, could be shipped to a variety of places for wholesale and retail. (Courtesy of the Salisbury Area Chamber of Commerce.)

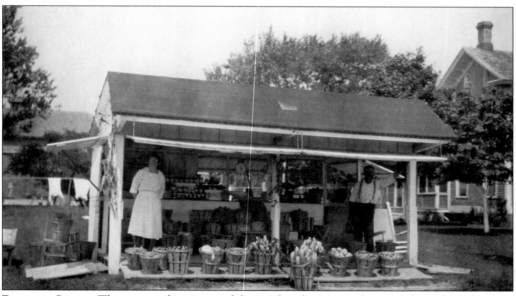

PRODUCE STAND. The most rudimentary of these sales places were fruit stands, such as this one, popular in the summertime along U.S. Route 50. Entrepreneurs running these booths hoped to attract customers as vacationers from Baltimore; Washington, D.C.; and beyond made their way through the city in droves en route to the beaches of nearby Ocean City. (Courtesy of the Salisbury Area Chamber of Commerce.)

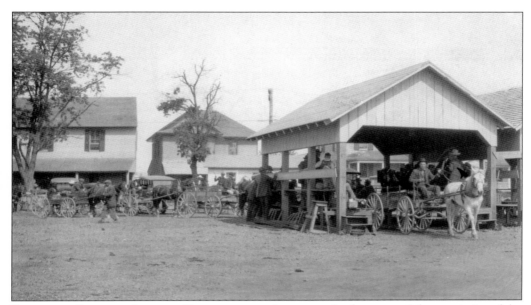

FRUITLAND PRODUCE AUCTION. For many years, farmers took advantage of the proximity of the popular produce auction block in nearby Fruitland. Buyers from local grocery stores to as far away as Chicago, representing chain grocers, attended the sales in hopes of attaining the best deals for their businesses. (Courtesy of the Salisbury Area Chamber of Commerce.)

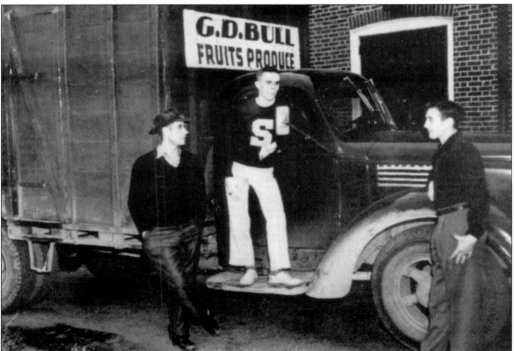

G. D. BULL PRODUCE, 1955. In later years, stores purchased from an intermediary buyer, such as G. D. Bull Produce. These companies would purchase fruits and vegetables from farmers in bulk, then resell them to local grocers. (Courtesy of Salisbury University.)

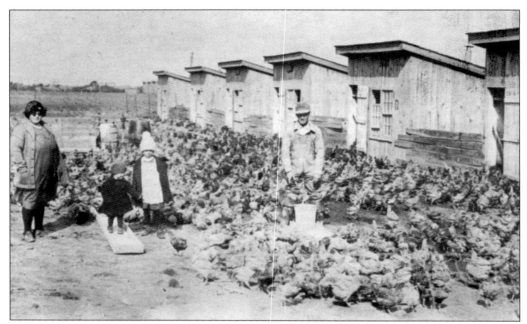

MRS. WILMER STEELE. Today agriculture in Salisbury is synonymous with the broiler chicken industry. Mrs. Wilmer Steele of nearby Sussex County, Delaware, seen at the left in this photograph, is credited with founding that industry on the Delmarva Peninsula in 1923. (Courtesy of the Salisbury Area Chamber of Commerce.)

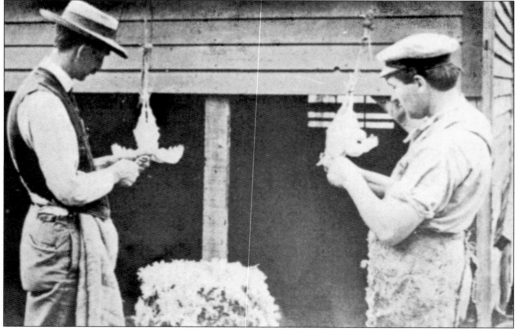

EARLY BROILER PRODUCTION. These chicken pluckers demonstrate the labor that went into early broiler production. Today machines perform the de-feathering process that was once done by hand. (Courtesy of the Salisbury Area Chamber of Commerce.)

VACCINATING THE CHICKS.
As the industry expanded, poultry producers learned the importance of vaccinations in keeping their flocks healthy. Shots like these help prevent chickens from acquiring and spreading diseases including cholera and fowl pox. (Courtesy of the Salisbury Area Chamber of Commerce.)

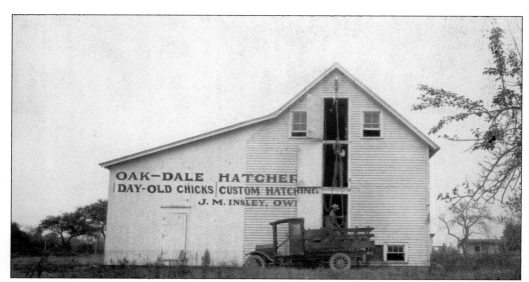

OAK-DALE HATCHERY. Before the broiler industry took off, local poultry farmers made their living selling eggs and breeding chickens. At the Oak-Dale Hatchery, day-old chicks and purebred white leghorns were specialties. (Courtesy of the Salisbury Area Chamber of Commerce.)

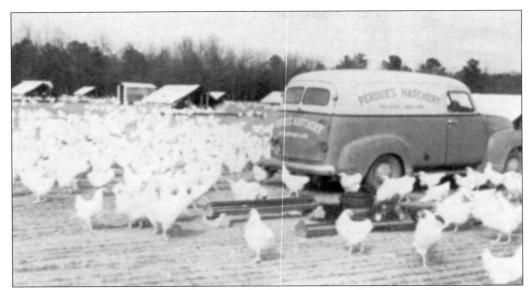

A. W. Perdue and Son. Railroad agent Arthur W. Perdue saw a future in the hatchery business, starting his own company in 1920. Three years later, he raised his first flock of broilers, starting the company on the road to international success. Today that small hatchery has grown into Perdue Incorporated, one of the world's most recognized brands. (Courtesy of the Salisbury Area Chamber of Commerce.)

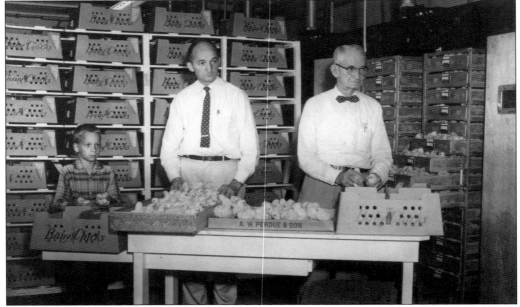

Three Generations of Leadership, 1955. In 1939, Frank Perdue (center) joined his father, Arthur (right), in the family business. Contracting with local growers, the company continued to expand, opening its first processing plant in Salisbury in 1968. Shortly thereafter, Frank began appearing in a decades-long run of television commercials that made him and the business famous. Frank's son, Jim Perdue (left), became chairman of the company in 1991. (Courtesy of Perdue Incorporated.)

Nine

FIRE AND OTHER DISASTERS

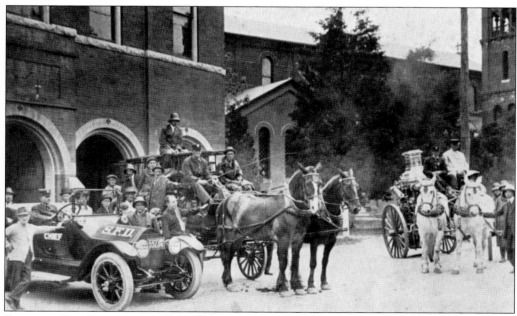

SALISBURY FIRE DEPARTMENT. The Salisbury Fire Department, as it is known today, was established on August 23, 1872, funded through sales of a fire subscription service. Firefighters responded only to the property of subscribers. It became a municipal unit in 1879, funded by the city and serving all residents. For many years, it was headquartered in what is now known as the "old" city hall building on St. Peter's Street. (Courtesy of the Salisbury Area Chamber of Commerce.)

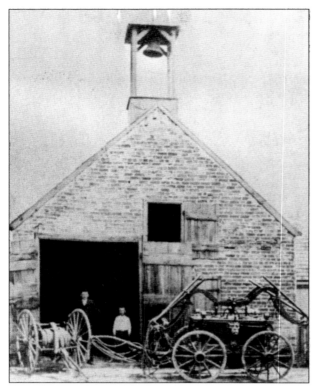

FIRST FIREHOUSE. The city's first at-large fire service began years earlier, in 1812, when a lottery was held to raise $10,000 for a pumper wagon, equipment, and firehouse on Humphreys Pond, seen in this early photograph. The pumper, valued at $2,000, burned as firefighters battled the August 1860 blaze that destroyed St. Peter's Church. (Courtesy of the Salisbury Area Chamber of Commerce.)

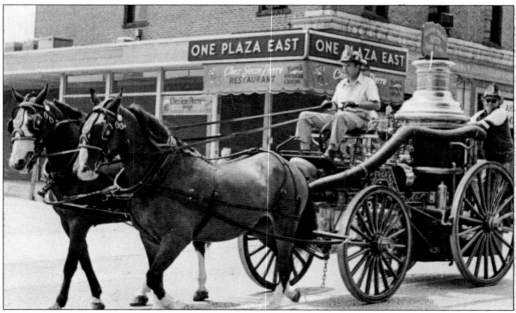

STEAM POWER COMES TO TOWN. As part of the agreement to provide municipal fire protection in 1879, city officials purchased this steam-operated Silsby fire engine at a cost of $4,100. In later years, the engine was used for ceremonial purposes, as seen here during a parade celebrating the city's 250th anniversary in 1982. (Courtesy of the Salisbury Area Chamber of Commerce.)

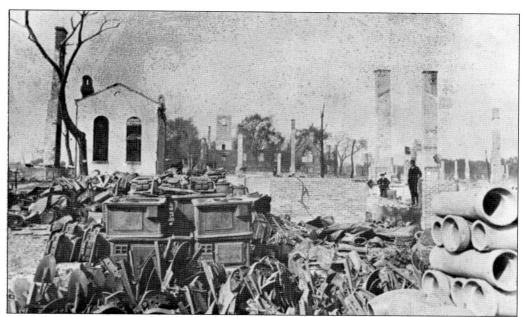

GREAT SALISBURY FIRE. The Silsby pumper was no match for the blaze that ripped through the city on October 17, 1886. Known as the Great Salisbury Fire, the inferno began at a livery stable on Dock Street (now known as Market Street) and quickly swept through the city's commercial district. Even with assistance provided by fire companies in nearby Crisfield and Pocomoke City, Maryland, and Wilmington, Delaware, 22 acres were burned. (Courtesy of the Salisbury Area Chamber of Commerce.)

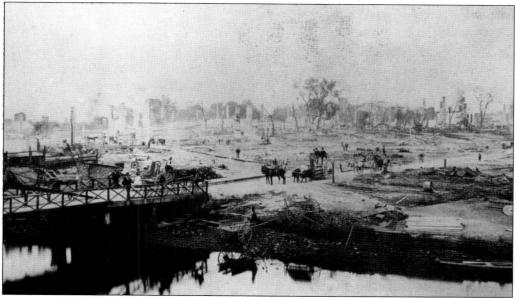

RUINS FROM THE RIVER. In all, estimates placed the damage at nearly $1 million. Casualties included Salisbury's original city hall and post office, St. Peter's Church, and over 200 homes and businesses. The result is seen here from the Wicomico River, near the Camden Bridge. (Courtesy of the Salisbury Area Chamber of Commerce.)

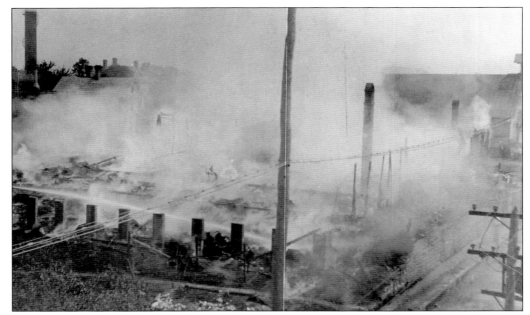

SALISBURY ARMORY FIRE, 1914. Salisbury's original armory on Church Street met its demise by fire at the same time construction of its replacement on South Division Street neared completion. Firefighters responding to the May 25, 1914, blaze were unable to save the old building, which, in addition to serving the National Guard, had been the site of many community dances and roller-skating events. (Courtesy of the Edward H. Nabb Research Center at Salisbury University, Wicomico Historical Society Collection.)

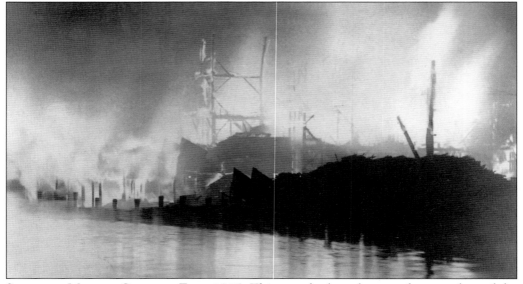

SALISBURY MILLING COMPANY FIRE, 1915. This was the last photograph ever taken of the Salisbury Milling Company's flour mill, which was not rebuilt following this March 3, 1915, fire. Along with the mill, the inferno claimed several thousand bushels of corn and wheat as well as an estimated 100 bushels of flour. Damages were estimated at $15,000. (Courtesy of the Edward H. Nabb Research Center at Salisbury University, Wicomico Historical Society Collection.)

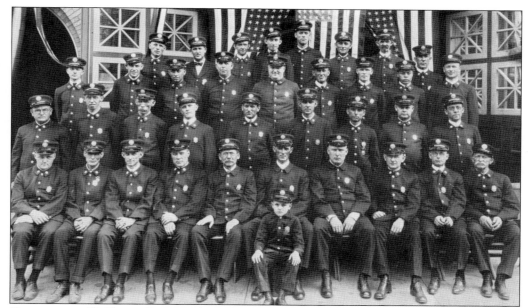

CELEBRATING 50 YEARS. Firemen showed off their dress uniforms in front of city hall to mark the 50th anniversary of the fire department in 1922. Though the building's tower was ornate, it served as more than just decoration. It was designed to be tall enough for the firefighters to hang their hoses from to dry. Each hose was about 60 feet long. (Courtesy of the Salisbury Area Chamber of Commerce.)

NEW FIRE DEPARTMENT HEADQUARTERS. The department moved into a new $55,000 building on South Division Street in 1928. The new fire headquarters remained in use for 80 years until late 2007, when operations were transferred to another newly constructed building on Cypress Street in 2008. The cost of the latest building was $9.2 million.

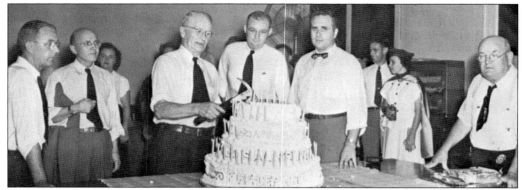

ANNIVERSARY PARTY. Firefighters celebrated the department's 76th anniversary in August 1948 at the South Division Street station. The first slice of cake was ceremoniously cut with an axe.

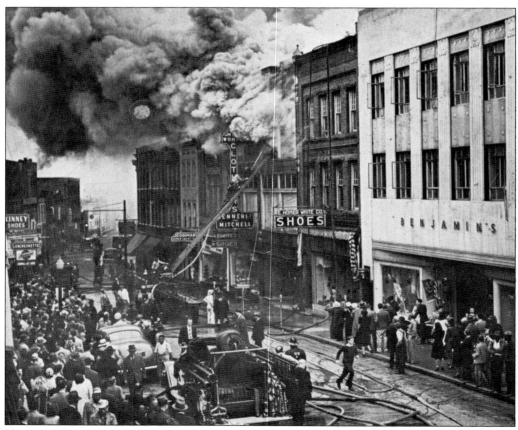

KENNERLY AND MITCHELL FIRE. Crowds gathered downtown to watch firefighters in action as the Kennerly and Mitchell clothing store building burned in May 1944. The fire marked the business's end. (Courtesy of the Salisbury Area Chamber of Commerce.)

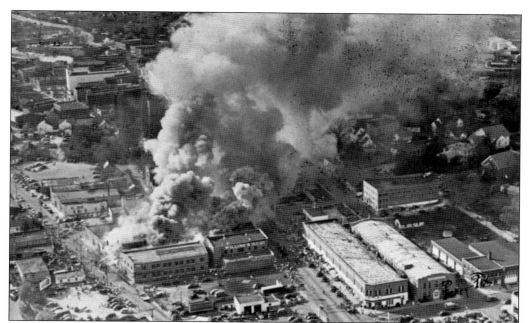

HUBERT R. WHITE HARDWARE FIRE. Another local business, Hubert R. White Hardware, burned in November 1946. Unlike Kennerly and Mitchell, the company recouped from the disaster and remained in business. (Courtesy of the Salisbury Area Chamber of Commerce.)

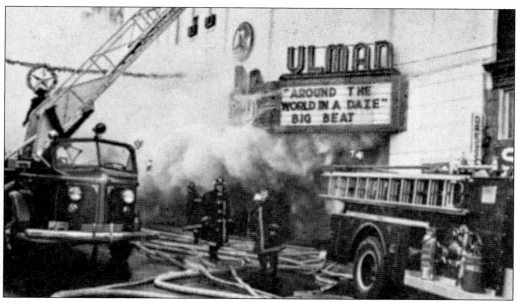

ULMAN THEATER FIRE. The Three Stooges, riding a new wave of popularity once their 1930s film shorts became available to a new generation on television in the late 1950s, starred in the feature film *Around the World in a Daze*, the Ulman Theater's marquee attraction when the building caught fire in December 1963. It was the last movie shown at the popular venue, which was not rebuilt. (Courtesy of the Salisbury Area Chamber of Commerce.)

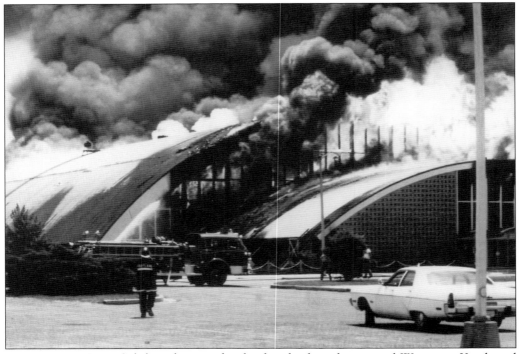

CIVIC CENTER FIRE. Salisbury lost another landmark when the original Wicomico Youth and Civic Center was destroyed by fire in 1977. Approximately 100 youth attending an arts and crafts workshop inside were evacuated. A charred plank from the inaugural building was mounted in its replacement's entryway, where it remains today, as a reminder of the devastating event. (Courtesy of the Edward H. Nabb Research Center at Salisbury University, Wicomico Historical Society Collection.)

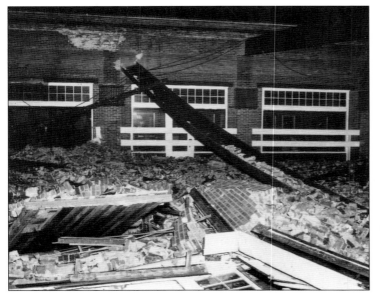

HURRICANE HAZEL. Not all catastrophes in Salisbury were the result of fire. In October 1954, Hurricane Hazel tore through the Delmarva Peninsula, leaving millions of dollars worth of destruction in its wake. This image shows the inside of a former automobile dealership at 111 South Baptist Street in its aftermath. (Courtesy of the Edward H. Nabb Research Center at Salisbury University, Wicomico Historical Society Collection.)

Ten

RECREATION AND
CELEBRATION

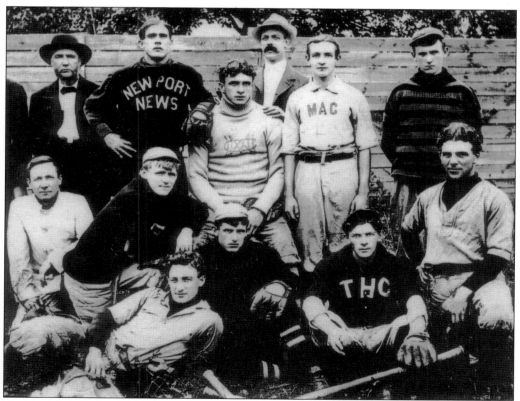

EARLY BASEBALL TEAM. Baseball has long been a popular pastime throughout the Delmarva Peninsula. Players identified in this early Salisbury team include George W. Bell (standing, back left), Henry Fooks (standing, center), Raymond K. Tull, and Virgil Ward (positions unidentified). (Courtesy of the Edward H. Nabb Research Center at Salisbury University, Wicomico Historical Society Collection.)

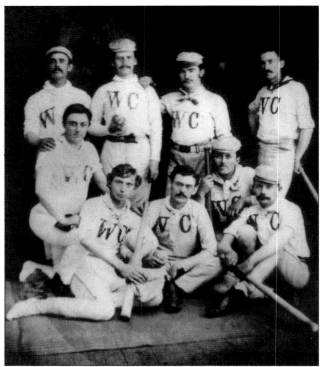

SALISBURY WHITE CLOUDS. The Salisbury White Clouds baseball team, also organized in the late 1800s, is said to have been the city's first professional team, preceding the Salisbury Indians of the Eastern Shore League. Seated in the center is local hardware store proprietor Louis W. Gunby. (Courtesy of the Edward H. Nabb Research Center at Salisbury University, Wicomico Historical Society Collection.)

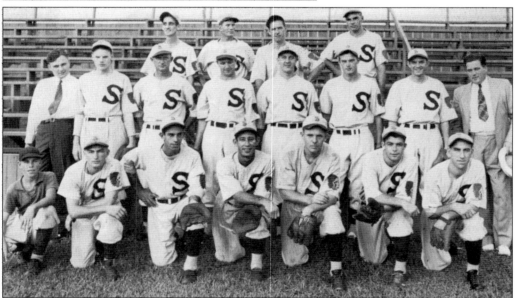

SALISBURY INDIANS, 1937. A farm team for the Washington Senators, the Indians played at Gordy Park, where the Salvation Army Youth Club is now located. Managed by D'Arcy "Jake" Flowers, who played on World Series teams with the St. Louis Cardinals and went on to coach several other Major League Baseball teams, the Indians won the 1937 Eastern Shore League pennant following a September 9, 1937, win against the Centreville Colts. (Courtesy of the Salisbury Area Chamber of Commerce.)

CIRCUS PARADE, C. 1900. This early-20th-century century parade on Main Street marked the arrival of a circus in Salisbury. Circuses have long been a popular form of entertainment in the city, from smaller shows sponsored by local civic organizations to Ringling Brothers and Barnum and Bailey, which often includes Salisbury in its annual tour.

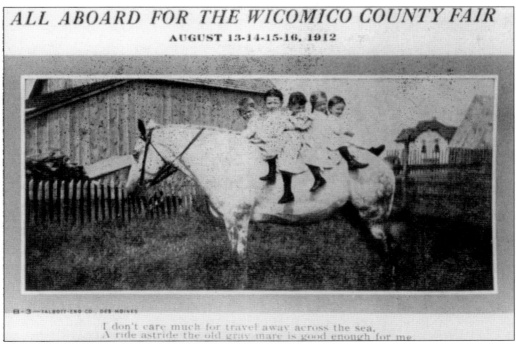

WICOMICO COUNTY FAIR, 1912. The First Wicomico County Fair was held August 17–20, 1909. A 3,500-seat grandstand was built atop a large exhibition building at the intersection of Parsons Road and Pemberton Drive. Those seated in the stands had the opportunity to watch the fair's annual marquee attraction—harness racing. The fair was held until 1933. (Courtesy of the Edward H. Nabb Research Center at Salisbury University, Wicomico Historical Society Collection.)

WOODROW WILSON VICTORY CELEBRATION. When Woodrow Wilson was elected U.S. president in 1912, he became only the second Democratic president since 1860. Local political supporters celebrated with a victory parade on Main Street.

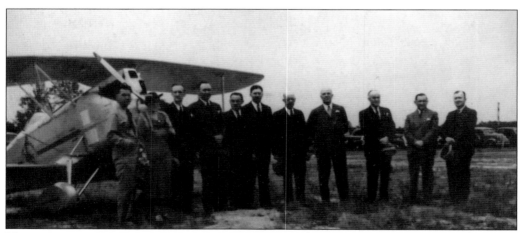

NATIONAL AIRMAIL WEEK. From left to right, A. E. Williams, Arthur W. Boyce, William S. Gordy Jr., William B. Tilghman Jr., and I. L. Benjamin were among those celebrating the 20th anniversary of airmail in Salisbury during National Airmail Week in this photograph, taken May 19, 1938. Wicomico County's airmail route was a circuit including Salisbury, Mardela Springs, and Hebron. (Courtesy of the Edward H. Nabb Research Center at Salisbury University, Wicomico Historical Society Collection.)

GREEN HILL YACHT AND COUNTRY CLUB. Seen here in the 1950s, Green Hill, located in nearby Quantico, Maryland, has served the Salisbury area since its founding in 1927. It has been home to several Professional Golfers Association section tournaments. (Courtesy of the Salisbury Area Chamber of Commerce.)

SALISBURY BICENTENNIAL CELEBRATION. In 1932, Salisbury celebrated its bicentennial with a weeklong series of events, including a special program at the Ulman Theater and a Main Street parade. Special guests attending included Maryland governor Albert Ritchie and Mayor Sidney Rambridge of Salisbury, England. Maryland comptroller William S. Gordy Jr. is seen at the podium. (Courtesy of the Edward H. Nabb Research Center at Salisbury University, Wicomico Historical Society Collection.)

SALISBURY COMMUNITY PLAYERS. Founded in 1938 under the Works Progress Administration, the Community Players of Salisbury is one of the oldest continuously operating theater troupes in Maryland. Its first production was *The Singapore Spider*, directed by Arthur Richardson at Asbury Church in May of that year. In this image, its members perform a Christmas production at Salisbury State Normal School's Holloway Hall Auditorium. (Courtesy of the Salisbury Area Chamber of Commerce.)

FRANKLIN D. ROOSEVELT VISITS. President Roosevelt visited several Eastern Shore municipalities, including Crisfield and Pocomoke City, during a tour of the Eastern Shore to promote Democratic candidates running for office in 1934. Salisbury was also on the agenda. Here the president is seen greeting supporters outside Wicomico High School.

MISS SALISBURY PAGEANT. Like many towns on the Eastern Shore, Salisbury once had its own namesake beauty queen. At the 1940 Miss Salisbury Pageant, the title was presented in several age—and two gender—categories.

SALISBURY CHRISTMAS PARADE, 1947. As the final soldiers from Salisbury returned from World War II in 1947, the Salisbury Jaycees made plans to celebrate with the city's first Christmas parade, less than a year after President Truman officially ended the United States' involvement. However, some reminders remained—like the surplus Jeep that towed Santa Claus's float down Main Street. (Courtesy of the Salisbury Jaycees.)

SALISBURY CHRISTMAS PARADE, 1950. The Wicomico High School marching band took the street during the fourth Christmas parade in 1950. Today the parade is the Salisbury Jaycees' longest continuously running annual project. (Courtesy of the Salisbury Jaycees.)

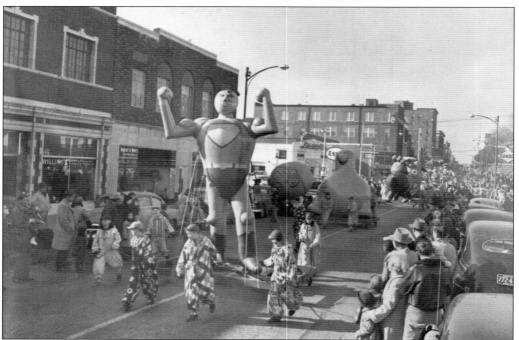

BALLOON FANTASY PARADE, 1951. In 1939, Superman became only the fourth character depicted as a balloon in the Macy's Christmas (now Thanksgiving Day) Parade in New York. A replica Superman balloon joined other inflatable entries at Salisbury's Christmas parade in 1951. The Jaycees sought to capitalize on these balloons' popularity, renaming the event the Balloon Fantasy Parade for several years in the 1950s before reverting back to its original title. (Courtesy of the Salisbury Jaycees.)

Jaycees Horse Show. The Jaycees were partial to horses during the organization's early years. Its first project during the chapter's inaugural year in 1940 brought harness racing back to the Wicomico County Fairgrounds for the first time since 1933 as part of a newly established strawberry festival. Several years later, it began an annual horse show, which continued into the late 1950s. (Courtesy of the Salisbury Jaycees.)

Delmarva Chicken Festival. Founded in 1948, the Delmarva Poultry Industry's annual Delmarva Chicken Festival features what is said to be the world's largest frying pan. The original, used from 1950 to 1998, weighed 650 pounds with a diameter of 10 feet and could cook 800 chicken quarters at once. Here members of the Salisbury Lions Club use its successor during the 2008 festival. Salisbury hosts the festival every few years, rotating with other Delmarva cities.

JAYCEES AIR SHOW. Another longtime favorite event, the Jaycees Air Show took place at the Salisbury Airport from the 1950s through the 1970s. Admission to the earliest events was just 50¢. (Courtesy of the Salisbury Area Chamber of Commerce.)

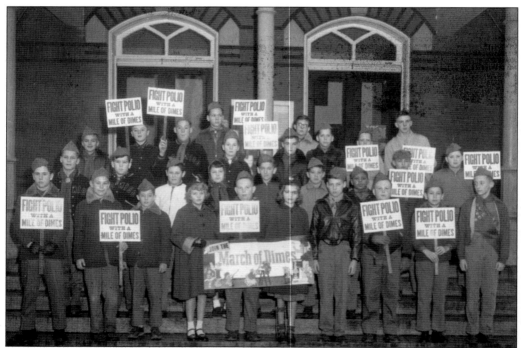

MARCH OF DIMES. In 1954, the Jaycees teamed up with local Boy and Girl Scouts to ask all local residents to join in the national campaign to contribute at least 10¢ each to the National Foundation for Infantile Paralysis's March of Dimes campaign to fund polio research. Once a vaccine was developed in 1955, the organization changed its mission to preventing premature birth, infant mortality, and birth defects. (Courtesy of the Salisbury Jaycees.)

INDEPENDENCE DAY. Starting in the 1940s, the Jaycees sponsored an annual Fourth of July celebration in City Park, featuring ice cream, lemonade, and children's activities including sack races and stilt walking. The decorated bicycle contest was a mainstay of the festivities. This family at the 1956 event encouraged residents to vote in that year's presidential election featuring candidates Dwight D. Eisenhower and Adlai Stevenson. The annual celebration continued until 1966. (Courtesy of the Salisbury Jaycees.)

TEEN-AGE ROAD-E-O. The Jaycees gave young drivers a chance to demonstrate their automotive skills on an obstacle course during the annual Teen-Age Road-E-O held for several years in the 1950s. The Pepsi-Cola Bottling Company of Salisbury cosponsored the event. (Courtesy of the Salisbury Jaycees.)

DUCK HUNTING. For many years, tourism guides to Salisbury and Wicomico County touted the area's vast open spaces for duck hunting. While there are fewer public spaces for that activity today, hunting and fishing remain popular pastimes for many local residents. (Courtesy of the Salisbury Area Chamber of Commerce.)

WRESTLING COMES TO SALISBURY. Television popularized professional wrestling in the 1950s. The Jaycees brought the sport to Salisbury live in 1957 during this charity matchup between Dr. Jerry Graham of Phoenix, Arizona, and Richard "Chief Big Heart" Vest of Pawhuska, Oklahoma. (Courtesy of the Salisbury Jaycees.)

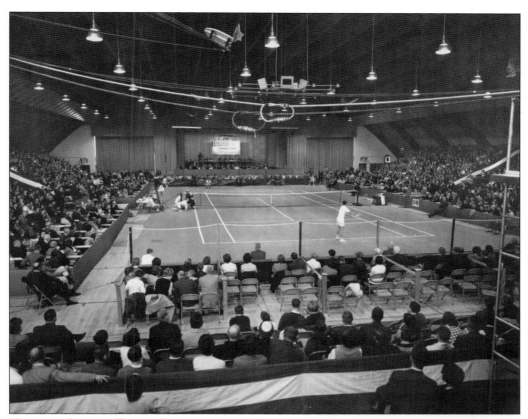

NATIONAL INDOOR TENNIS CHAMPIONSHIPS. In 1964, sports promoter William F. Riordan brought the National Indoor Tennis Championships to Salisbury. During its 13 years in the city, the event drew celebrity players including James Connors, Ille Nastase, and Arthur Ashe, who, in turn, brought national television coverage. In 1977, the championships left Salisbury for its new home in Memphis, Tennessee, where it remains today. (Courtesy of the Salisbury Area Chamber of Commerce.)

PURNELL-THOMAS MEMORIAL TENNIS TOURNAMENT. Professional tennis returned to Salisbury in 1982 with the Chris Thomas Memorial Tennis Tournament, named for a prominent local tennis advocate who died of cancer. Following a break from 1995 to 2003, the tournament returned in memory of Thomas and Salisbury athlete Jack Purnell, who died of cancer in 2002. Today the charity event is an international draw. Seen here is player Sargis Sargesian at one of the original Chris Thomas tournaments. (Courtesy of Michele Thomas.)

WARD WORLD WATERFOWL CARVING COMPETITION. Each year since 1971, the Ward Foundation has invited carvers from around the world to participate in the Ward World Waterfowl Carving Competition. The event—the largest of its kind on the planet—was held at the Wicomico Youth and Civic Center until the building burned in 1977. In 1978, the competition was moved to the Ocean City Convention Center, 30 miles east of Salisbury. (Courtesy of the Salisbury Area Chamber of Commerce.)

SISTER CITIES. When Gil Burden, the mayor of Salisbury, England, visited Salisbury, Maryland, in 1972, he was greeted not only by local elected officials, but also by U.S. vice president Spiro Agnew, a native of Maryland. Officials in Salisbury arranged for Burden to visit Agnew's White House office. Today Salisbury, England, is one of three sister cities to Salisbury, Maryland, along with Tartu, Estonia, and Dalian, China. (Courtesy of the Salisbury Area Chamber of Commerce.)

SALISBURY'S SESQUIBICENTENNIAL. In 1982, Salisbury celebrated its 250th anniversary with nine days of festivities including a parade, dances, sporting tournaments, a historical fashion show, reenactments, and guests from Salisbury, England. The celebration has been called one of the most memorable in the city's history. This float represents the event's grand marshals—former mayor Elmer F. Ruark and Charles J. Truitt Sr. (Courtesy of the Salisbury Area Chamber of Commerce.)

FIREMEN'S MUSTER. Firefighters throughout the Delmarva Peninsula exhibited their equipment, both new and old, and competed in an annual firemen's Olympics at this event, hosted for many years in City Park. The last muster was held in 2005. (Courtesy of the Salisbury Area Chamber of Commerce.)

SALISBURY FESTIVAL. Founded by the Salisbury Area Chamber of Commerce in 1982, the Salisbury Festival is held each April along the city's downtown Riverwalk. The annual event brings residents of the city together to celebrate the coming of spring and provides fund-raising opportunities for many local civic organizations. (Courtesy of the Salisbury Area Chamber of Commerce.)

WINTER WONDERLAND OF LIGHTS. This popular Christmas light display in City Park was suspended in 2005 when it became the target of municipal government cutbacks. A private citizens group was formed to raise money to reestablish the project, and the lights returned to the park in 2006. (Courtesy of the Salisbury Area Chamber of Commerce.)

PORK IN THE PARK. In 2004, the Wicomico County Department of Recreation, Parks, and Tourism founded Pork in the Park, an annual barbecue competition at Salisbury's Winterplace Park sanctioned by the Kansas City Barbeque Society (KCBS). By 2010, the event had grown to over 135 teams, making it the second largest KCBS competition in the United States.

SALISBURY CELEBRATES 275 YEARS. After reading a newspaper article that stated the City of Salisbury had declined to plan a celebration for its 275th anniversary, the Salisbury Jaycees stepped in. With just three weeks to go before the anniversary date, the chapter organized a reception and afternoon of historical presentations. Pictured under the banners are presenter Dr. G. Ray Thompson (left, seated) of Salisbury University and WBOC anchorman Jimmy Hoppa (right, at the podium), who served as master of ceremonies.

www.arcadiapublishing.com

Discover books about the town where you grew up, the cities where your friends and families live, the town where your parents met, or even that retirement spot you've been dreaming about. Our Web site provides history lovers with exclusive deals, advanced notification about new titles, e-mail alerts of author events, and much more.

MADE IN THE USA

Arcadia Publishing, the leading local history publisher in the United States, is committed to making history accessible and meaningful through publishing books that celebrate and preserve the heritage of America's people and places. Consistent with our mission to preserve history on a local level, this book was printed in South Carolina on American-made paper and manufactured entirely in the United States.

This book carries the accredited Forest Stewardship Council (FSC) label and is printed on 100 percent FSC-certified paper. Products carrying the FSC label are independently certified to assure consumers that they come from forests that are managed to meet the social, economic, and ecological needs of present and future generations.

FSC
Mixed Sources
Product group from well-managed forests and other controlled sources

Cert no. SW-COC-001530
www.fsc.org
© 1996 Forest Stewardship Council

Find Your Place in History.